IMAGES
of America

CINCINNATI
ART DECO

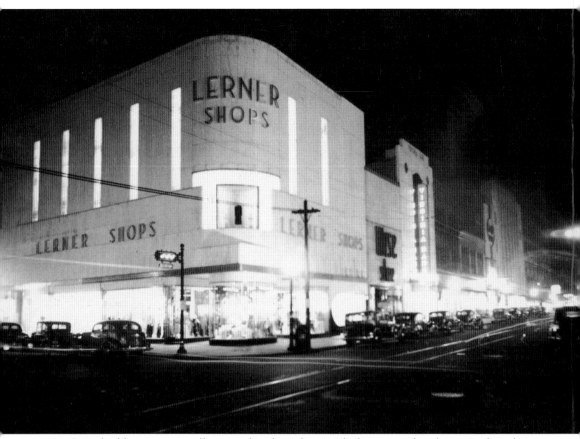

Art Deco buildings were usually streamlined, modern, and often somewhat daring in their design. Lerner Shops seems to protrude towards the viewer like a knife, as seen in this vintage nighttime photograph. (Courtesy of the Ohio Historical Society SA1039AV_B02F14_015_1.)

ON THE COVER: Looking at this Art Deco masterpiece, it is hard to imagine that architect John Henri Deeken made his reputation by designing stately, English-style mansions. In 1937, he was commissioned by the Coca-Cola Bottling Company to design its Cincinnati facility. The result was this astonishing work, captured here by the famed Cincinnati photographer Paul Briol. (Courtesy of the Cincinnati Museum Center, Cincinnati Historical Society Library.)

IMAGES of America
CINCINNATI ART DECO

Steven J. Rolfes and Douglas R. Weise

Copyright © 2014 by Steven J. Rolfes and Douglas R. Weise
ISBN 978-1-4671-1200-0

Published by Arcadia Publishing
Charleston, South Carolina

Printed in the United States of America

Library of Congress Control Number: 2013953315
For all general information, please contact Arcadia Publishing:
Telephone 843-853-2070
Fax 843-853-0044
E-mail sales@arcadiapublishing.com
For customer service and orders:
Toll-Free 1-888-313-2665

Visit us on the Internet at www.arcadiapublishing.com

To Judy and Isabelle Weise and all Cincinnatians who preceded us, great and small, who made this city so remarkable; also, to the memory of James Rolfes (1998–2013).

Contents

Acknowledgments		6
Introduction		7
1.	The Art Deco Years	11
2.	Union Terminal	19
3.	The Netherland Plaza	47
4.	The Times-Star Building and Other Downtown Deco	71
5.	Art Deco in the Cincinnati Area	87
6.	Cincinnati Postwar Modern	119

ACKNOWLEDGMENTS

This book would not have been possible without the help of several very supportive people.

We would like to thank everyone associated with the Public Library of Cincinnati and Hamilton County, the Greater Cincinnati Memory Project, the Southwest Ohio and Neighboring Libraries, and the Ohio Historical Society. We would also like to thank the Kenton County Public Library and the Cincinnati History Library and Archives.

Thanks go to Sharyn Speckman, president of the North College Hill Historical Society; Rebecca Strand Johnson, the Pogue family, the people at the Delhi Historical Society, and Penny Huber and David Huser of the Mt. Healthy Historical Society. Thanks also go to Sandy Nagel at North Presbyterian Church and Karen F. Maier, vice president of marketing at Frisch's Restaurants.

We especially thank Phil Lind for graciously sharing several outstanding photographs from his collection. Thanks and appreciation go to Michel Sheer, Bob Louis, and Peter Goldstein at the Hilton Netherland Plaza, and to Douglass W. McDonald and Elizabeth Pierce at the Cincinnati Museum Center at Union Terminal. Many thanks go to John Williams and the great folks at the 20th Century Theater.

Thanks go to our acquisitions editors at Arcadia, Mary Margaret Schley for getting this book off the ground and Jesse Darland for seeing it through to completion.

We thank our families for all of their help and support, especially Jordan Rolfes of Beagle Rampant Productions, for the beautiful photographs and hours of technical support.

As always, we thank our Lord for his many blessings.

INTRODUCTION

If you wish to understand history, look at economics. If you wish to understand a society, look at its art.

It was Robert Bonfils who created the famous poster for the 1925 *Exposition internationale des arts décoratifs et industriels modernes*. The poster, modern and daring, is in just two colors. It depicts a barefoot nymph running from right to left. Just behind her is a stylized gazelle. The nymph and the gazelle are at the same spot, apparently running at the same speed. Had this poster been made two decades earlier, it no doubt would have been filled with flowers and cherubs, the woman depicted in realistic hues. Rather than racing with a gazelle, she probably would have been standing majestically. Now, in this new age, she was a surprisingly simple drawing, with very few features to denote her. Her stature was sleek, modern, and most importantly, in motion.

Art Deco, a term that was not invented until the 1960s, was not born in the great French exposition, but, rather, amidst the pain and bloodshed in the trenches that scarred Europe seven years earlier. When an average, insignificant man, Gavrilo Princip, gunned down the Archduke Ferdinand, in Sarajevo in 1914, it set off a disastrous chain of events. These aftermaths, brought on by a commoner, utterly and completely transformed the entire world and the course of history. When the smoke cleared and the bodies were buried, the world became a very different place. Princip had murdered not just one nobleman, but the entire dynasty of the Hapsburgs, the Hohenzollerns, the Romanovs—even the ancient House of Osman, which ruled the Ottoman Dynasty (although the halife remained as a figurehead, and would not be formally exiled until 1924)—were gone. In place of these outdated monarchies came a new world—the world of the common man. With the exception of Russia, these nations charged into the new century, ready to grab history by the collar and take it to places where it had never been before. Now, they had a new art form to symbolize this rise of the common man, all of which was given form on a poster for a world's fair.

Art and architecture experts constantly argue and subdivide the genre. For example, the category known as Art Moderne is a smoothly streamlined and Modernist style often limited in, or devoid of, decorations. As Germany entered the wild time of the Weimar Republic, Walter Gropius helped to create the school of architecture known as Bauhaus, combining modernism with an emphasis on function over form. Other forms of Art Deco, such as the French style, feature a great deal of ornamentation, often combined with more traditional styles.

Art Deco was more than just architecture. It influenced traditional art, such as the paintings of Tamara de Lempicka and Hildreth Meiere, the sculptures of Demetre Chiparus, Antoine Bourdelle, and Willard Stone, and many other artists and genres. From glassworks to symphonies to architecture, this modern style captured the spirit of the times—restless and defiant, ready to grab hold of the future and ride it like a charging bull. Thus it bears to reason that much of Art Deco is streamlined and, like the character in that original poster, in motion.

One of the most enjoyable places to look at Art Deco is in film. Perhaps the definitive "deco moment" in the cinema is that stunning scene of a suicidal Fred Astaire and Ginger Rogers

dancing on a Modernist rooftop to "Let's Face the Music and Dance" in the 1936 film *Follow the Fleet*. Both of the characters are ready to commit suicide after losing their money: Astaire, from gambling and who, along with Rogers, is about to jump off of the roof—as so many Wall Street executives had done. Instead, they defy poverty (i.e., the Great Depression) and dance. Of course, the classic film scene, the one which most truly captures the spirit of Art Deco, is in Merian Cooper's 1933 *King Kong*. Here, the ultimate individual, Kong, has climbed to the pinnacle of the greatest Art Deco building of all time, the newly erected Empire State Building. Despite the biplanes shooting at him, the great individual strikes back, swatting helplessly as he is defiant to the oppression of technology. The ape dies not in a cage, but as a free creature, defiant to the end. Of course, we all know it was beauty that killed the beast.

Art Deco is the art of defiance, of the individual, of progress and the future. The covers of Ayn Rand's novels are invariably decorated with Art Deco designs.

This design and art form propelled the nation through the period of Prohibition, the Roaring Twenties, when it reflected an unprecedented spirit of rebelliousness. It was the common people who defied the intentions of reformers who used the government to impose their morality on the masses. Art Deco has always represented the individual, not the collective.

Later, the winds of fortune changed. During the 1930s, Art Deco boosted the morale of the people who wished to prosper despite the Great Depression.

The challenges did not stop when the Great Depression was abruptly ended by World War II. Art Deco was born in the trenches of World War I and finally faded when the veterans returned from the bloody beaches of the Pacific and the heartland of Europe. Once again, a new world was created when the smoke cleared, this time from a mushroom cloud. With this frightening new world came a new form of art and design.

Unlike Art Deco, this new genre does not really have a name. It is merely referred to as Postwar Modern or sometimes even Fabulous Fifties. Nowadays, it is often referred to by the somewhat satirical moniker Retro. This is in many ways a mistake. Retro would refer to something going backwards, away from progress and the future. In truth, the Postwar Modern Style was the exact opposite, and, in a spiritual sense, it was in merely the next step in Art Deco. It was again very modern, streamlined, and optimistic. It reflected a restless society very much on the move, now in automobiles with large fins rather than trains. This new form went beyond the bounds of the earlier style in that it reflected the new frontier of mankind: outer space. There is a cosmic feel to this genre, best exemplified in the Disney parks' Tomorrowland sections. This is the style, which lasted into the early 1960s, is found in the popular prime-time animated series *The Jetsons*. This was the art of the space age. With the 1950s also came the Brutalism style, from the French words *béton brut*, literally "raw concrete."

To understand Art Deco in Cincinnati, one must consider the history. In the 1920s and 1930s, Cincinnati experienced three major historical events. The first took place during the Roaring Twenties, the Jazz Age with its bathtub gin and bootleg whiskey.

When one hears of Roaring Twenties gangsters, he usually thinks of Al Capone in Chicago. Few remember that one of the most powerful and certainly wealthiest racketeers was based right here in Cincinnati: George Remus, the "King of the Bootleggers."

Most who are familiar with Remus today probably know him only through the popular HBO series *Boardwalk Empire*. He is depicted in the show as something of a buffoon, almost a comical figure. The real man was very different, and, as it turned out, very dangerous.

Born in Germany in 1874, Remus was five when he immigrated with his parents to Chicago. There, he rose from poverty to first become a pharmacist, and later a lawyer. When Prohibition was imposed on an unwilling American public, Remus began to defend minor gagsters arrested for violating the Volstead Act. Seeing how much money these mostly uneducated thugs had earned, he decided that he could do better. He could use his brains and his legal training to form a truly organized bootlegging empire and in the process become wealthy himself.

Knowing that Cincinnati was filled with thirsty Germans, Remus moved to the Queen City and began his operation on the Gehrum farm, near Queen City Avenue. He did indeed establish a bootlegging empire that was second to none, becoming so wealthy that at a New Year's Eve

party he gave away diamond necklaces and new cars as party favors. His operation was spread over several states, including sending liquor back to his old home of Chicago.

Eventually, Remus's network of bribed officials collapsed when the federal government arrested him in 1927. Convicted and sentenced to two years in a federal penitentiary, he asked his wife, Imogene, to "get in good" with the man who had arrested him, agent Frank Dodge.

The result was not what he expected. Imogene got in a little bit too good with the officer, eventually running away with him. To finance her new love life, she cleaned out the Price Hill mansion on Hermosa Avenue (the site of the mansion is now a row of ordinary-looking apartment buildings). Finally released from prison, George returned home to find that even the carpets from the floor were gone. He eventually caught up with his errant wife at the Eden Park gazebo, where he shot her. She died hours later.

Rather than face life as a fugitive, Remus the lawyer turned himself in and was determined to defend himself in court. His opponent was none other than Hamilton County prosecutor Charles Taft, son of American president and later chief justice William Howard Taft. It seemed an impossible task for Remus, the bootlegger and self-confessed killer, to beat such an open-and-shut case against such a strong opponent.

However, Remus had known all along that the people of Cincinnati hated Prohibition, loved beer and whiskey, and loved him. He pleaded not guilty by temporary insanity. He won the case.

Eventually, Prohibition was repealed. Remus had moved to northern Kentucky by then, but life would not return to normal. Cincinnati, like the rest of the nation, was in the grips of a terrible economic depression. In the midst of this, Franklin Roosevelt was elected president to combat the economic doldrums. He instituted a number of government agencies to help the poor and unemployed.

As Roosevelt was taking the oath for his second term in January 1937, it was raining—not only in Cincinnati and Washington, but throughout the entire Ohio River valley. The rain just would not stop. Soon, the entire region was engulfed in a flood far beyond anything that had ever been recorded before.

Cincinnati had only recently shaken off the last remnants of the political machine of its Gilded Age dictator, George "Boss" Cox. Now, to consolidate and speed along relief efforts, Cincinnati voluntarily put itself under a new dictator, City Manager Clarence Dykstra.

This new dictator certainly had his job cut out for him. The flood had reached the unbelievable depth of 79.9 feet, a full 10 feet above the previous massive inundation of 1884. The downtown basin area to Third Street, the East End, Northside-Cumminsville, and many other areas were submerged. Water and electric service were disrupted. No one could bathe; everyone ate by candlelight and could only have a single bulb and a radio using power.

In the midst of this tragedy came what has been known as Black Sunday. On Spring Grove Avenue at Arlington Street, near an oil refinery and the Crosley manufacturing plant, a single live wire from a streetcar line collapsed into the floodwater. Unfortunately, the water had a heavy coat of oil and petroleum from overturned storage tanks that had been lifted off of their foundations. The resulting explosion and fire spanned blocks. Fire crews raced to the scene from as far away as Dayton. One fireman was found literally frozen to his hose, nearly dead from the freezing temperature. It took an entire day for the fire to be brought under control.

Eventually, the river receded, and the great disaster of 1937 was over. However, a few short years later, the world was once again plunged into madness—as for a second time, the entire world was involved in another great war. When it ended, what had been Art Deco had become something different, unique to a new, postwar America.

Cincinnati is fortunate to have numerous examples of Art Deco, three of which are overwhelming in their design. The most famous is the Art Moderne–style Union Terminal. It was at this magnificent setting that many servicemen hugged their families and sweethearts goodbye before departing, some never to return.

After the war, the railroads declined, leaving Cincinnati with a stunning but essentially useless masterpiece. For some time, it was deserted. Eventually, an investor attempted to turn it into a shopping mall. This failed, prompting some to suggest the unthinkable: tearing it down.

However, it was saved by being converted into the Cincinnati Museum Center, today housing three permanent museums, an Omnimax theater, and traveling special exhibitions.

Downtown is rich with examples of Art Deco, particularly the Netherland Hilton and Carew Tower. This was the brainchild of John J. Emery, who had to sell stock holdings to fund the new skyscraper. Construction on this ambitious project began in September 1929. A month later, the stock market crashed; thus, creating the building actually saved the Emery fortune from ruin.

The Netherland was meticulously decorated in a French Art Deco style, and is to this day world famous for its elegance. The main ballroom, the legendary Hall of Mirrors, was inspired by the Palace of Versailles. Throughout the hotel, one can see murals that are classical and baroque mixed with the Art Deco setting.

Set off in the northeast corner of the downtown area is the Times-Star Building, taking Art Deco to a massive scale. This was the creation of the second generation of Hannafords. Samuel Hannaford had given the city some of its finest buildings, including Music Hall and the city hall. All of his creations were overwhelming, and his sons learned well, constructing the Dalton Street Post Office, another Art Deco treasure.

There are numerous other examples of Art Deco throughout the city, many of which are shown in this volume. There many are others that simply could not fit in. The outlying city of Fairfax boasts two Art Deco manufacturing facilities located right next to each other. A wonderful Art Deco building on the northwest corner of Park Avenue and William Howard Taft Road is now a church. A trip up Queen City Avenue passes a waterworks building in grand 1930s style. If one chooses to turn onto Harrison Avenue instead, there are numerous such edifices going up through Westwood into Cheviot. Indeed, Art Deco is seemingly everywhere in the Cincinnati area.

Postwar Modernism of the late 1940s and 1950s can boast of the Terrace Plaza Hotel on Sixth Street. This masterpiece of modernism was revolutionary in that much of it was designed by a woman, Natalie de Blois. Sadly, this is one treasure that is lost, as the hotel finally closed in 2008. Happily, due to the work of Thomas Emery, the great Joan Miró mural and Alexander Calder mobile from the hotel can be seen today at the Cincinnati Art Museum.

Some Art Deco and Postwar Modernist buildings are disappearing under the wrecking ball. Other classic buildings have been saved by being converted to other purposes. Union Terminal, once a busy railroad depot, now houses dinosaur bones and relics of Old Cincinnati. The Coca-Cola Bottling Company Building, depicted on the cover, is now the Alumni Center for Xavier University. The gargantuan Times-Star Building now houses courts and county offices. Downtown's Shillito's and the American Building have been converted into condominiums.

Art Deco once did not have a name; it was simply modern. But like everything that is new and fresh, it was destined to someday find its way into antique shops or be placed in historic registers. But what of the spirit of optimism and defiance that was the real life force of Art Deco? Is that now an antique, or do we still have it today?

One
THE ART DECO YEARS

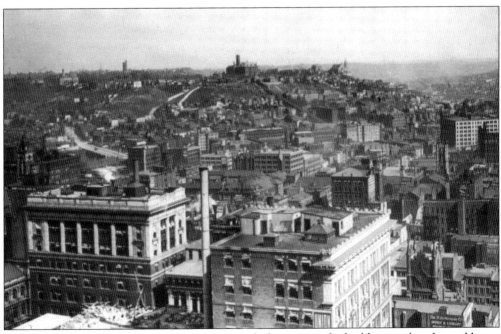

This old postcard shows that Cincinnati was proud of its spectacular buildings and ready to add even more daring and visionary designs. The most classical building shown here, the ornate chamber of commerce, would burn down in a disastrous fire; it would later be replaced by the more modern Union Central Tower. (Courtesy of the Public Library of Cincinnati and Hamilton County.)

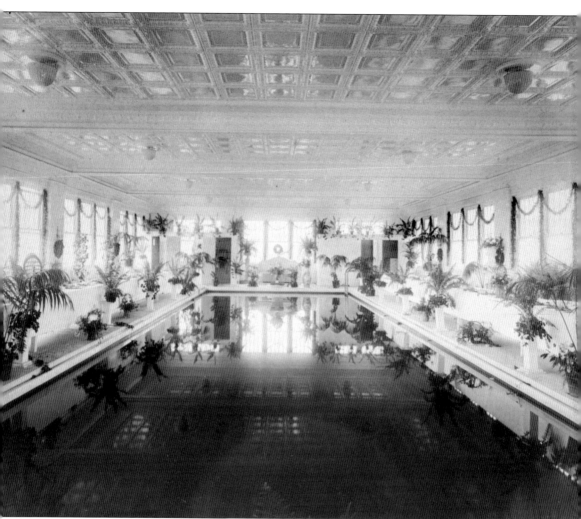

While this pool looks like part of a luxury hotel, it was actually located in a private residence. The indoor swimming pool of Cincinnati's George Remus, "the King of the Bootleggers," is Roaring Twenties gangster opulence at its height. Remus's massive empire distributed illegal whiskey to thirsty customers throughout the Midwest, even sending some of his supply back to his old hometown of Chicago. Remus was born in Germany in 1874 and immigrated to the United States as a child. An ambitious and intelligent man, by his early twenties he became a pharmacist and soon owned two drugstores. He later became a successful lawyer. When Prohibition began, Remus moved to the heavily German city of Cincinnati and used his pharmaceutical credentials and legal skills to set up a bootlegging operation on the Gehrum farm on Queen City Avenue. His dominion flourished, allowing him to purchase this grandiose mansion, known as the Marble Palace, on Hermosa Avenue in upper Price Hill. He was arrested in 1925. (Courtesy of the Public Library of Cincinnati and Hamilton County.)

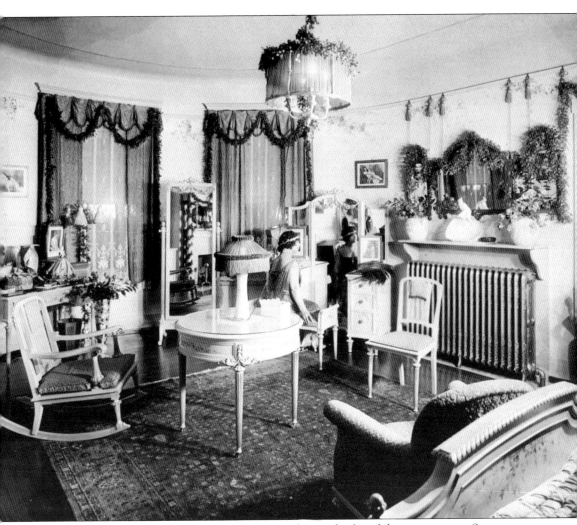

This is a rare photograph of one of the two great femme fatales of the gangster era. Seven years before the "Lady in Red," Anna Sage (Cumpânas), brought down John Dillinger in front of the Biograph Theater in 1934, this Cincinnati woman betrayed a dangerous gangster and paid for it with her life. This is Imogene Remus, wife of George Remus, the largest Roaring Twenties bootlegger in the country. Although she did not contribute to his arrest for bootlegging, she later ran off with the man who apprehended him, cleaning out Remus as he languished in prison in Atlanta. This scene is from happier times in their Price Hill mansion, as she prepares for her appearance at the memorable New Year's Eve party in 1922. The party favors for the lucky guests included new automobiles and diamond necklaces. (Courtesy of the Public Library of Cincinnati and Hamilton County.)

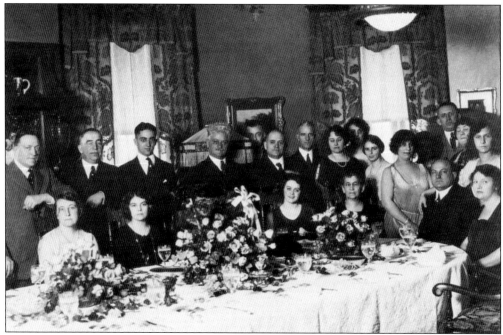

This extremely rare photograph shows a family gathering of the Roaring Twenties gangster George Remus. He is seated on the right in this photograph. Moving left, his infamous wife, Imogene, is seen standing, leaning on his shoulder. Remus's mother is seen here seated to his right. (Courtesy of the Delhi Historical Society, the Pogue family, and Jack Doll.)

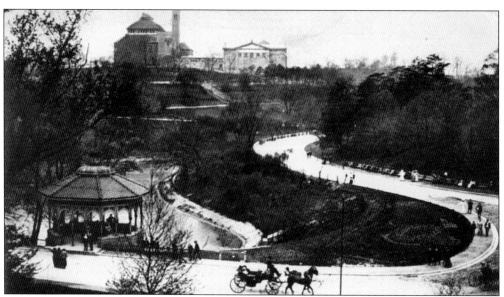

Eden Park's Moorish gazebo is where one of the darkest murders of the 1920s occurred. Imogene Remus left the Alms Hotel in a taxi to finalize her divorce. George Remus pursued the cab, forcing it off the road. He then chased and shot her. He defended himself, claiming "temporary insanity." Given his popularity in Cincinnati, the jury was convinced. (Courtesy of the Kenton County Public Library, Covington, Kentucky.)

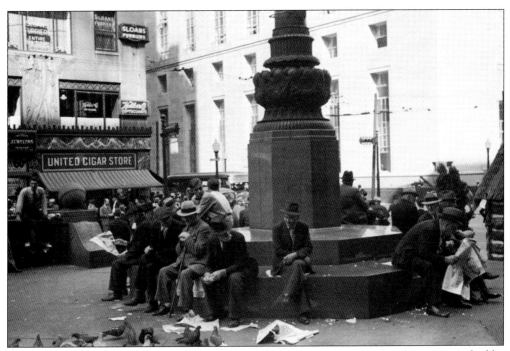

After the wildness of the Roaring Twenties, the 1930s was a demandingly sober time marked by the Great Depression. Like other manufacturing cities, Cincinnati was hit hard by the economic disaster. Seen here are a number of men sitting on Fountain Square, scouring the classifieds in the newspaper. Judging from the litter on the ground, it can be assumed that their luck was not good. (Library of Congress LC-USF33-001218-M3.)

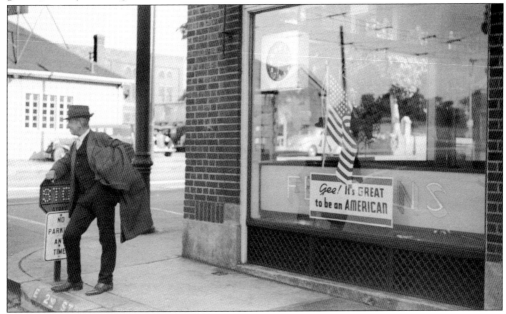

In this Depression-era scene from Second Street in Covington, Kentucky, a storefront sign, complete with Old Glory, touts how good it is to be an American. The man with a ragged hat keeps his back turned to the optimistic message. (Library of Congress LC-USF33-T01-001675-M2.)

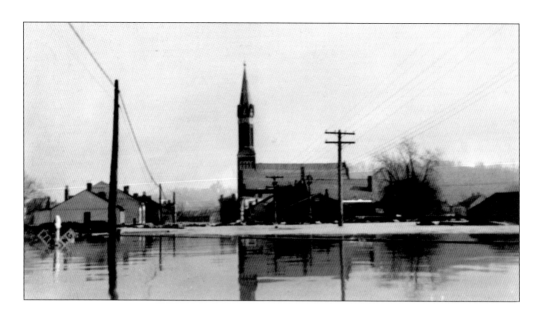

In 1937, as Franklin Roosevelt was being sworn in for his second term, a freak weather pattern caused unending rainfall in the Ohio Valley. The largest city affected by the unprecedented flooding was Cincinnati. Seen here, the crest was an unbelievable 79.9 feet, nearly 10 feet higher than the previous record set in 1884. To deal with the emergency, the Cincinnati City Council appointed City Manager Clarence Dykstra as temporary dictator with sweeping powers. Amidst the chaos, not only was water and electric power severely rationed, but an entire neighborhood was nearly burned to the ground. When streetcar cables fell into floodwater coated with oil, a massive fire erupted near the Crosley facility on Spring Grove Avenue. The resulting inferno was so horrendous that President Roosevelt personally inquired as to the condition of the city. The New Deal agencies, particularly the WPA, along with a massive army of unpaid volunteers, worked hard to feed and clothe refugees, rescue people in boats, deliver water, and place sandbags in threatened areas. (Both, courtesy of the North Presbyterian Church.)

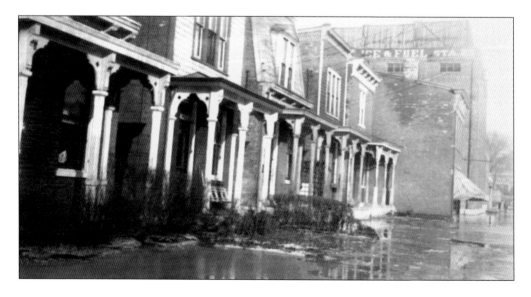

The agencies of the New Deal, which were of such value during the 1937 flood, were busy throughout the Depression. Not only did the WPA assign men manual labor (like constructing the beautiful stone walls in Eden Park), the program also included writers and even theatrical productions, such as this presentation of The Mikado. (Library of Congress LC-USZC2-5402.)

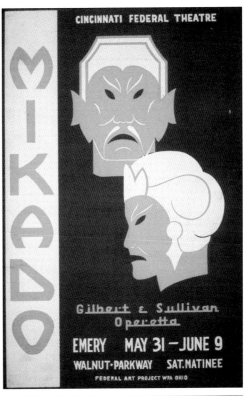

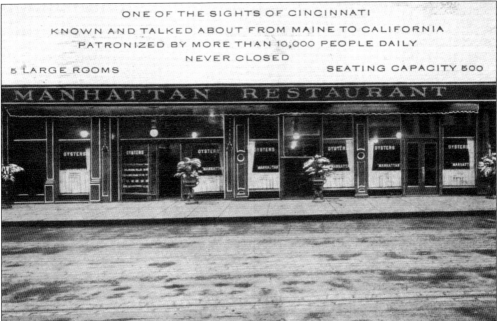

This early example of the Art Deco style looks like something out of a movie. However, it was a real restaurant, so popular that it served 10,000 hungry Cincinnatians each day. The ownership and name had changed in 1906 when one of the employees purchased the business and named it the Manhattan. (Courtesy of the Public Library of Cincinnati and Hamilton County.)

Art Deco, which included product design, was certainly streamlined. However, modern chefs might hesitate before trying out this vintage toaster. It may look sleek and modern, but one might want to check the fire insurance before using it. This antiquated appliance is on display in a small museum run by the Mt. Healthy Historical Society. (Photograph by Jordan Rolfes.)

Art Deco design was not only found in traditional artwork and architecture, but also in graphic arts. This music teacher wanted to attract potential students by demonstrating an understanding of modern trends, such as being on the cutting edge of radio announcing or singing. (Library of Congress LC-USZC2—5655.)

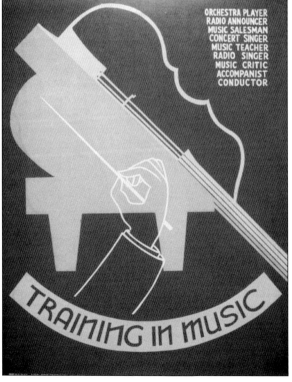

Two
UNION TERMINAL

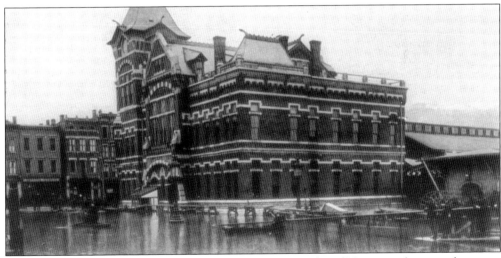

Cincinnati's downtown railroad depots were glorious examples of Victorian elegance; there was, however, one major problem. Being located close to the Ohio River, these wonderful buildings were useless for anything but fishing during the occasional floods. After 1884's great flood, presidents of the railroads decided to look for land to build one major depot far away from the river. (Courtesy of the Public Library of Cincinnati and Hamilton County.)

From the time of the Civil War to the beginning of the 20th century, Cincinnati was one of the major railroad junctions in the nation. In 1880, when the concept of Union Terminal was first discussed, Cincinnati had more rail connections than Chicago. (Courtesy of the Kenton County Public Library, Covington, Kentucky.)

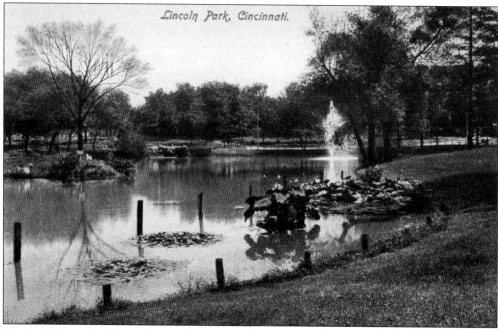

The land chosen for Union Terminal was Lincoln Park in the West End. Before this, it had been a wide variety of things over the years. It began as a stone quarry, became a cricket field, and was then used as the first ballpark for the Cincinnati Red Stockings—the first professional baseball team. (Courtesy of the Public Library of Cincinnati and Hamilton County.)

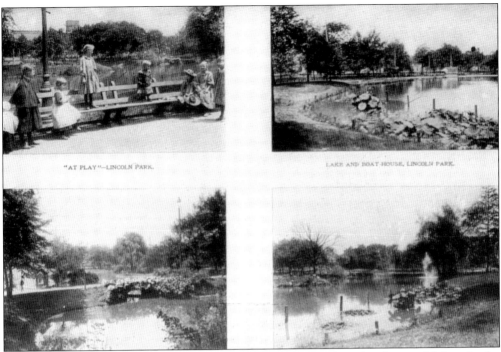

Children would swim in Lincoln Park's lake. On hot summer days, families would sleep in the cool air of the park. When it became a depot, the tradition continued, as children would remove their outer clothing and jump in the fountain, after which the family would sleep in the terminal. Today, the museum center frowns on this practice. (Courtesy of the Public Library of Cincinnati and Hamilton County.)

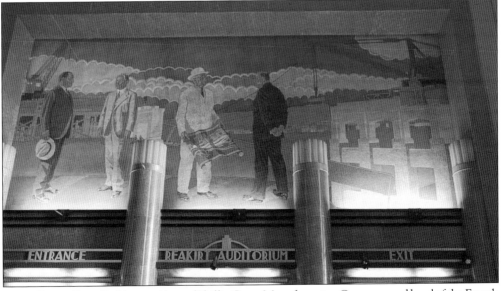

It was George Dent Crabbs, president of Phillip Carey Manufacturing Company and head of the Fourth District Federal Reserve Bank, who finally decided that 20 years of studying an issue was long enough. He brought together the seven different heads of railroads to create one central terminal to serve the entire city. He is seen in the mural with his hands behind his back. (Photograph by Jordan Rolfes.)

After years of endless discussion and debate, construction of the Union Terminal finally began. It was very fortunate that any work was done at all considering the timing. The first shovels of dirt were turned two months after the crash of the stock market, which plunged the nation into the Great Depression. (Courtesy of the Kenton County Public Library, Covington, Kentucky.)

While the building was ready for occupancy in 1931, the railroads were dragging their feet moving in. However, another flood, this one in 1933, reminded everyone exactly why this new building was constructed. The railroads quickly relocated their operations away from the unpredictable Ohio River. (Courtesy of the Kenton County Public Library, Covington, Kentucky.)

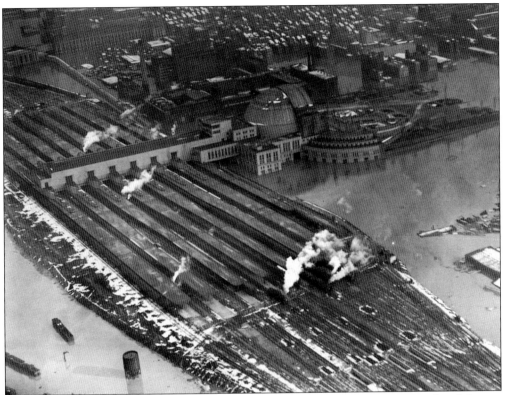

Union Terminal had been built as an answer to floods devastating downtown railroad depots. However, no one could have predicted the monstrous 1937 inundation. Even so, the design of the building withstood even this unparalleled assault by the Ohio River. However, the streets around the facility were flooded, forcing it to close anyway. It became an Art Deco island in an inland sea. (Courtesy of Phil Lind.)

This view is from the Dalton Street tunnel underneath the terminal, facing Gest Street during the 1937 flood. The flood cut off Union Terminal and submerged much of the Art Deco post office nearby. (Courtesy of the Kenton County Public Library, Covington, Kentucky.)

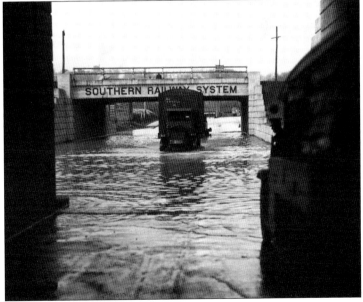

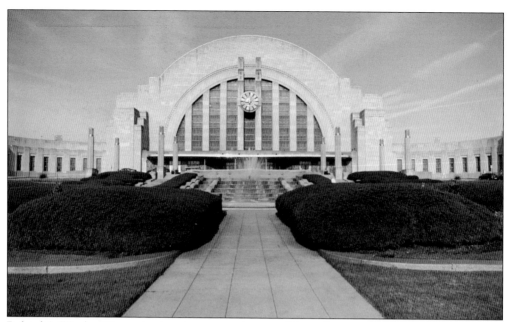

Roland A. Wank, a Hungarian immigrant, was the part of the architectural team that determined the Art Moderne look of the building. Originally, hard as it is to believe today, the plans were for a classical building in much the style of the earlier depots it was to replace. Wank encouraged backers to adopt the Art Deco design, stating that it would save them money. (Photograph by Doug Weise.)

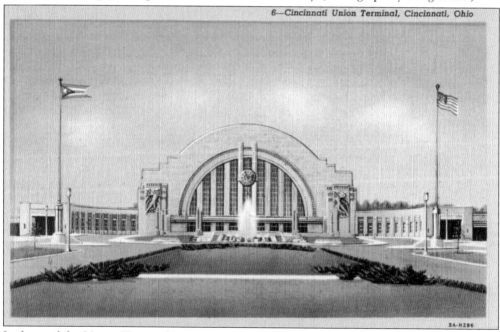

In front of the Union Terminal are two massive bas-reliefs. One is Hermes, the Greek god of commerce, denoting Industry. The other, a female figure with a train at her feet, represents Transportation. These 20-foot-tall icons were the work of famed sculptor Maxfield Keck. New Yorkers were familiar with his work on the Waldorf-Astoria, the New York Telephone Building, and the Riverside Church. (Courtesy of the Kenton County Public Library, Covington, Kentucky.)

This is a close-up view of Maxfield Keck's relief on the north side of the building. It depicts Hermes, the classical deity of commerce, communication, and messenger of the gods. He was also the patron of merchants and thieves. However, the eagle at his feet is symbolic of his father, Zeus. Note the lettering on the date beneath the figure. (Photograph by Doug Weise.)

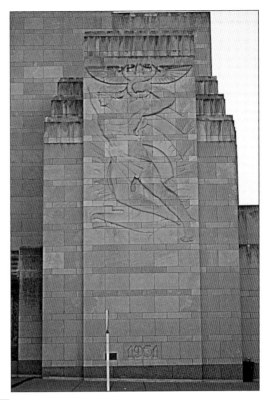

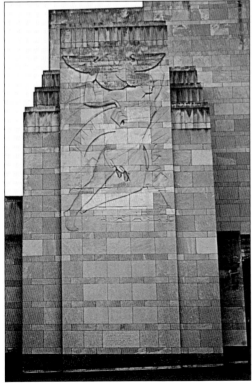

Facing Hermes on the other side of the entrance is this female allegorical figure depicting Transportation, a winged globe on her back. Behind her is a rising sun, denoting hope and prosperity, even in the time of the Great Depression. Appropriately, at her feet is the image of a locomotive. (Photograph by Doug Weise.)

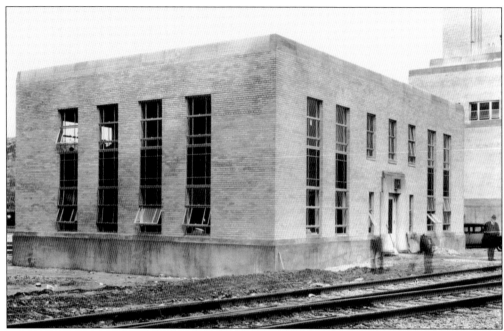

While most photographs show Union Terminal's dramatic front with the half shell rotunda, this rare shot demonstrates that the attention to artistic detail and Moderne design extends to areas that are not usually visible to the public. Even here, the windows are long and vertical. (Courtesy of the Kenton County Public Library, Covington, Kentucky.)

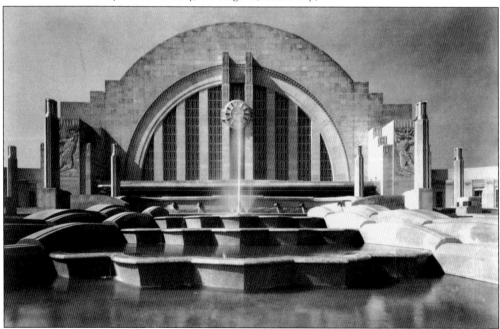

It is difficult to open any book on classic Art Deco architecture without seeing a photograph of this masterpiece. The sleek walls are made of shimmering Indiana limestone. The clock is thirty feet in diameter. The big hand alone is more than nine feet long, the small one more than seven. (Courtesy of the Kenton County Public Library, Covington, Kentucky.)

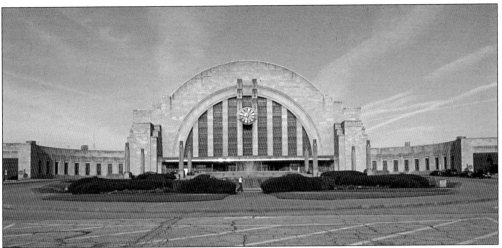

For 42 years, Union Terminal's unique shape made it the largest half-dome in the entire world. However, in 1973, this record was taken away by a building Down Under when Danish architect Jørn Utzon constructed the Sydney Opera House. While still modern and daring, it is definitely not Art Deco. (Photograph by Doug Weise.)

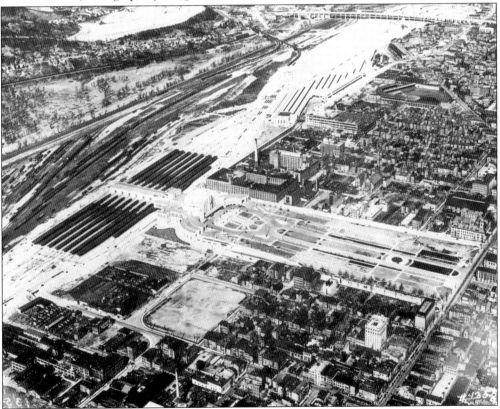

As this building is a museum today, it is easy to forget that this was once a train station. In this old aerial view is an area that is no longer in existence; behind the building was the zone where people got on the trains. The concourse itself was 450 feet long. The platforms extended for more than 1,500 feet. (Courtesy of Phil Lind.)

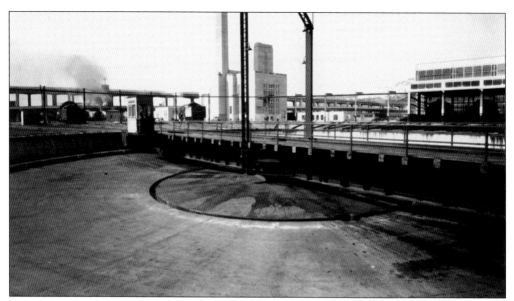

This rare photograph shows a sight at Union Terminal that very few people ever had the opportunity to see. This is the great turntable near the Engine House. In the background is one of the rear buildings that still has the Art Deco look. (Courtesy of the Kenton County Public Library, Covington, Kentucky.)

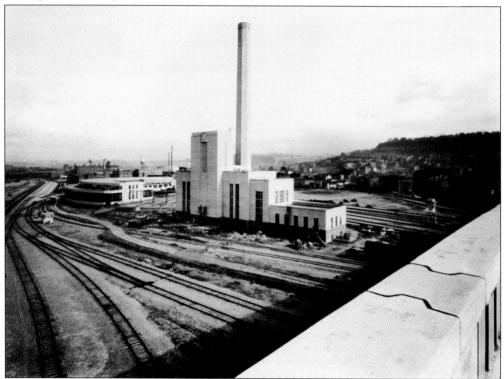

The massive smokestack and Moderne style of the buildings give this structure a look that would be at home in Fritz Lang's *Metropolis*. However, it is simply another one of the buildings behind Union Terminal. (Courtesy of the Kenton County Public Library, Covington, Kentucky.)

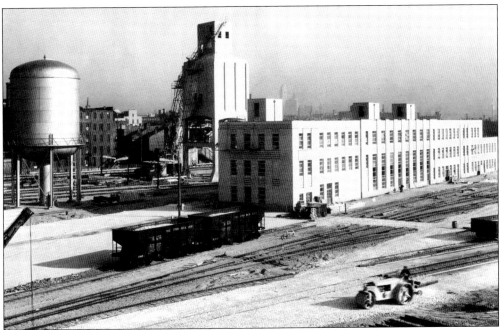

This interesting shot gives an idea of the bustling activity that was nonstop at this major railroad hub. Notice the size of the water tank located near the service building on the southeast side of the complex. An astute viewer can just barely make out the Art Deco skyscraper the Carew Tower in the distance. (Courtesy of the Kenton County Public Library, Covington, Kentucky.)

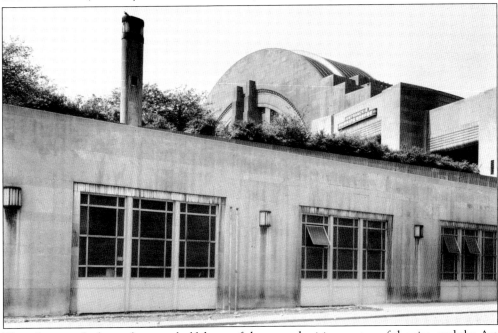

This photograph shows the great half-dome of the rotunda rising on top of the rise, and the Art Deco pattern continuing even in places not open to the public. The writing on the entrance of the southern wing of the building states that it was the entrance to the parking garage. (Courtesy of the Kenton County Public Library, Covington, Kentucky.)

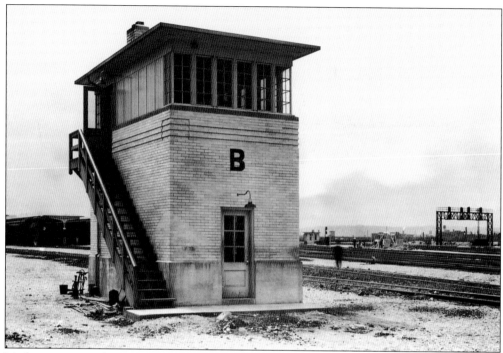

Modern visitors to the museum center can experience some of the operations of the old observation tower. Those who visit on the weekends should ask to see Tower A, the tower that controlled the trains and placed them on different tracks. This free attraction, staffed by railroad enthusiasts, still overlooks the rail yard. (Courtesy of the Kenton County Public Library, Covington, Kentucky.)

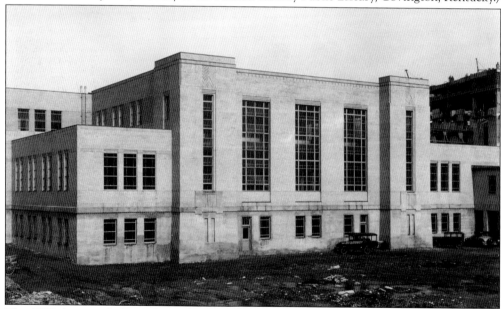

This 1933 photograph shows the mail handling building. Although this structure was on the south side of the station and not visible to the public, the Art Deco style of architecture is continued here as well. Hundreds of mail sacks passed each day through this department of the terminal. (Courtesy of the Kenton County Public Library, Covington, Kentucky.)

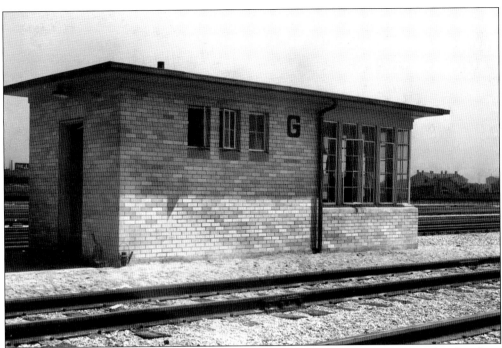

Humble little Cabin G, located far out in the rail yard, was a place that was only seen by railroad workers. However, even here some of the Modernist features of the main building are visible. For instance, notice how tall the door is. (Courtesy of the Kenton County Public Library, Covington, Kentucky.)

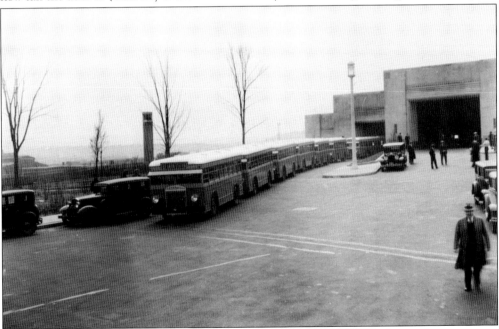

Union Terminal was designed to keep everyone moving forward. This applied not only to passenger and trains, but other transportation as well. Buses and taxis would enter the building through the north end of the structure, discharge near the platforms, proceed on to pick up passengers, then exit through the south side. (Courtesy of Phil Lind.)

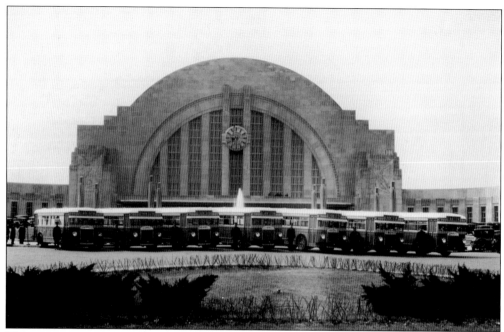

There was so much bus service going in and out of Union Terminal that by 1944, the transit authority had to assign two supervisors to handle the motor coach traffic in the facility. This was, not surprisingly, known as Route U. There is still a special bus route for the building today, connecting the museum center to Eden Park and the art museum. (Courtesy of Phil Lind.)

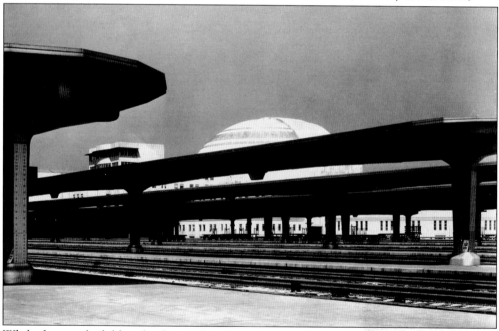

While this may look like a landing pad for flying saucers, this is actually the reason that people came to Union Terminal: the passenger boarding area behind the building. Although this ornate area no longer exists today, Amtrak passengers still board their trains at Union Terminal. (Courtesy of the Kenton County Public Library, Covington, Kentucky.)

While the outside of the structure is stunning, with the back of the building especially fascinating to railroad enthusiasts, the inside shows Art Deco at its zenith. Just walking through the front doors into the massive rotunda gives one the feeling of entering another world. Notice the light fixtures at the entrance. (Photograph by Doug Weise.)

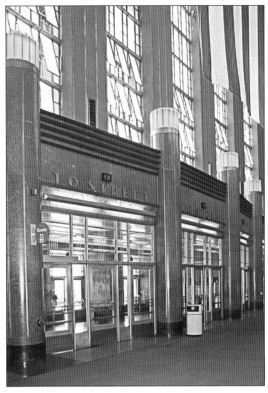

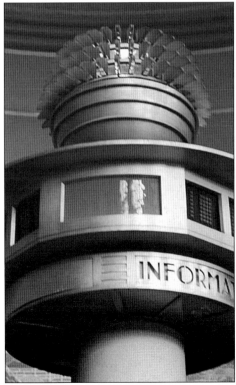

This remarkable bit of artwork, now located on top of the ticket kiosk for the museums, is rarely noticed by visitors. Underneath this dazzling sphere is a digital clock, sadly no longer functioning. It is possibly the oldest digital clock in a public space anywhere in the world. (Photograph by Jordan Rolfes.)

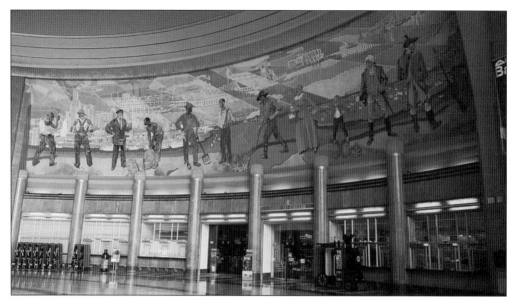

One of the most striking features of Union Terminal is artist Winold Reiss's gigantic mural that surrounds the rotunda. Reiss came to the United States to study the traditional art of Native American cultures. His many murals, seen both in the terminal and the Greater Cincinnati Airport, depict Progress, Transportation, and Industry. (Photograph by Jordan Rolfes.)

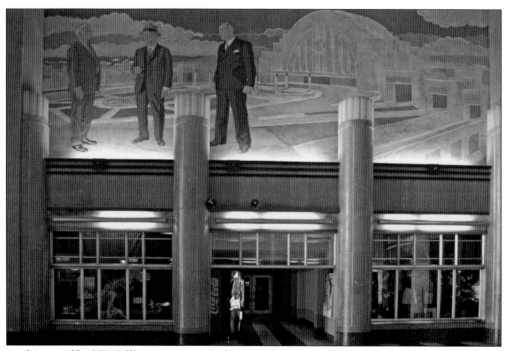

Architect Alfred T. Fellheimer certainly knew a thing or two about designing train stations. He was one of the junior partners who designed New York's stunning Grand Central Terminal. Partnering with Steward Wagner, he designed Union Terminal to have "utility, efficiency and honesty of expression." It would appear that he succeeded. (Photograph by Doug Weise.)

Union Terminal was designed to handle thousands of people each day, constantly moving them forward so that there would be no need for unnecessary backtracking. However, a world war was not in the planners' vision. During the height of the troops departing the city, the number of people making their way through the rotunda swelled to more than 34,000. (Photograph by Doug Weise.)

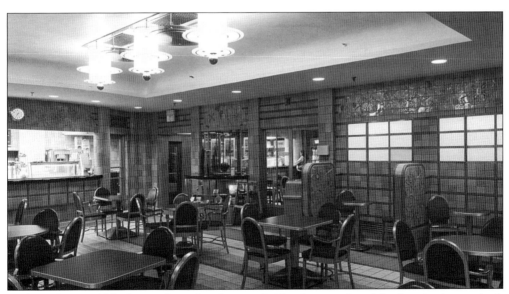

Rail travelers would find everything that they needed for their comfort right there in the terminal. Among the amenities was a toy shop to keep the children amused, a theater, and numerous places to eat, including the elegant Rookwood Tea Room. This unique restaurant is now an ice cream parlor. Notice the light fixtures on the ceiling. (Photograph by Jordan Rolfes.)

Besides the areas open to the museum visitors, there are numerous behind-the-scenes pieces of Art Deco that are rarely seen. (Photograph by Jordan Rolfes.)

When the Union Terminal opened in 1933, a number of large railroads had their offices right in this building. Shown here is a room overflowing with Art Deco splendor. But this is not the president's office; this is merely for the secretary. Behind those ornate doors with the frosted glass is an Art Deco lover's treasure. (Photograph by Jordan Rolfes.)

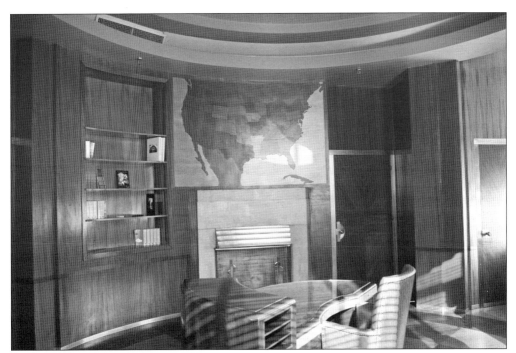

Once one has passed the secretary outside, this is the inner sanctum behind the beautiful frosted-glass doors. Surprisingly, this railroad president's office is rather small, but it is filled with Art Deco wonders, right down to the stunning fireplace. In true Art Moderne style, the office itself is circular. (Photograph by Doug Weise.)

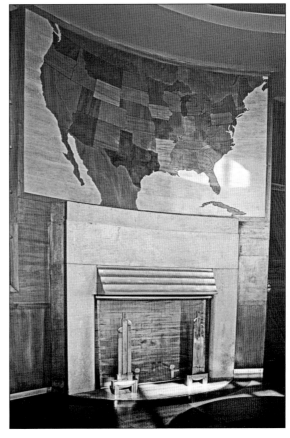

There is a curious story behind these magnificent fireplace andirons in the president's office. When rail service was discontinued in Union Terminal, the building was falling into disrepair. People would walk in and cart away whatever they wished. These unique andirons were among the items stolen. Thankfully, when the building reopened as a museum center, the people were honest and dutifully returned them. (Photograph by Doug Weise.)

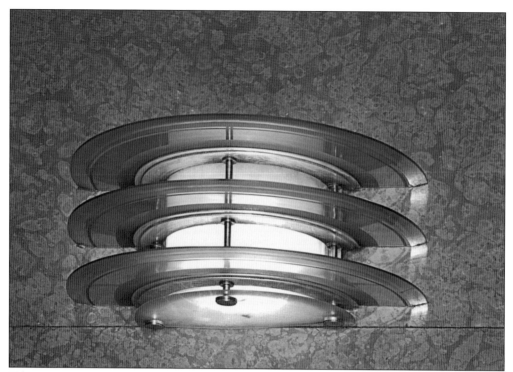

Whenever a person has the opportunity to visit an Art Deco building, some of the features that he or she should always pay close attention to are the light fixtures. There are a number of different Modernist designs of such fixtures located throughout the Union Terminal, such as this rather cosmic style. (Photograph by Doug Weise.)

Some of the finest Art Deco treasures in Union Terminal are, unfortunately, found in an area that is not generally open to the public. On the south side of the rotunda, near the food vendors, is a private dining area that can be rented for special events. In here is one of the most fascinating features of the building. (Photograph by Jordan Rolfes.)

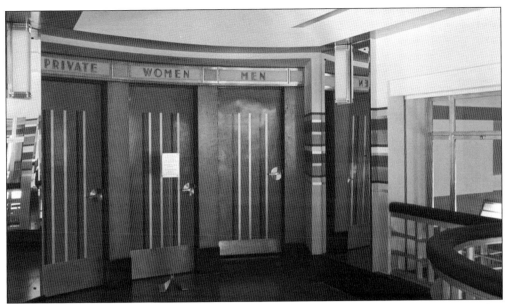

Even the restrooms are decorated in stunning Art Deco fashion in this private dining area. Today, everyone from politicians to those celebrating Christmas office parties uses this facility to add elegance to meetings and events. (Photograph by Jordan Rolfes.)

This banquet area was once a restaurant where travelers would have quick meals. In the private dining room, there is a second banquet area in the back. Those visiting this area should look up to the ceiling. In the corners of the ceiling mural in this second exclusive dining hall are depictions of various forms of transportation. Naturally, among them is a train. (Photograph by Doug Weise.)

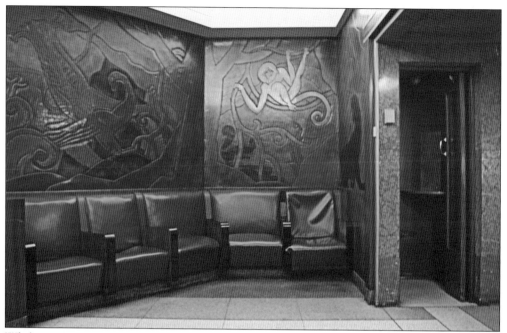

While everyone can enjoy Winold Reiss's murals, some of the most amazing pieces of art found in Union Terminal are located in this banquet area not often seen by visitors. This is the collection of Pierre Bourdelle's tropical-themed murals, located in the entrance to the Women's Lounge in the restaurant. (Photograph by Doug Weise.)

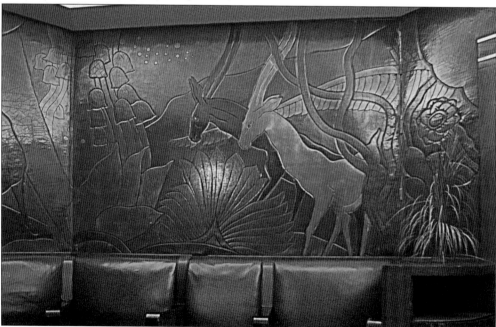

Bourdelle was not only a great artist whose work even appeared in Haiti's former presidential palace, but he was also a man of action. He was shot down as a fighter pilot in World War I and journeyed back to France after the German invasion, parachuting behind enemy lines. He fought with the French resistance and served with the Foreign Legion. (Photograph by Doug Weise.)

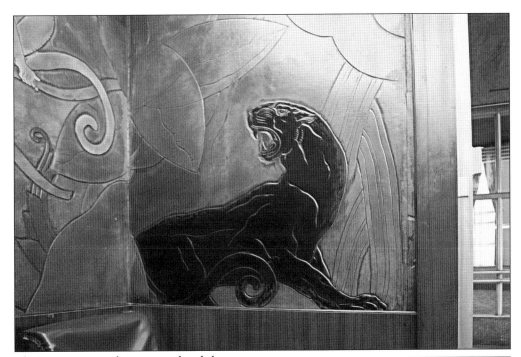

This stunning panther is considered the signature piece of the series. Like Art Deco itself, Bourdelle's style was influenced by the horrors of World War I. There, he was wounded and became deaf. Among the most memorable locations of his art besides Union Terminal are on board the luxury ocean liner SS *America* and, ironically, on a train, the famous California Zephyr. (Photograph by Doug Weise.)

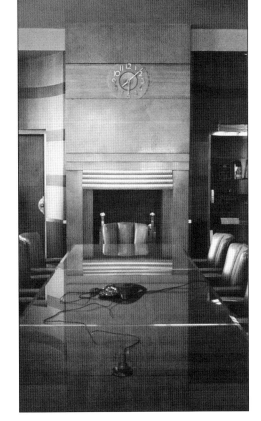

While patrons of banquets and meetings may have the opportunity to view Bourdelle's colorful masterpieces, this is a corner of Union Terminal that is almost never seen by the general public. This is one of the meeting rooms. Once again, note the andirons in the fireplace and, of course, the Modernist design of the clock. (Photograph by Jordan Rolfes.)

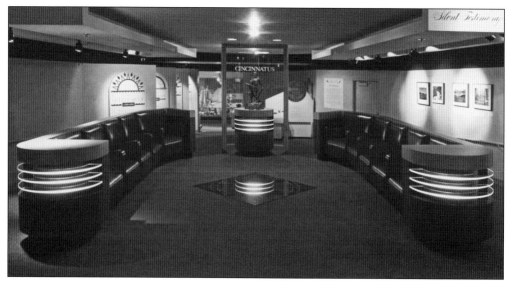

Some of the most stunning pieces of Art Deco furnishing are these seats, located in the Cincinnati History Museum. In the background is a small statue commemorating the Roman politician Cincinnatus, the namesake of Cincinnati, who left his farm in a time of war to serve the Roman people. After leading the troops to victory, he returned to his farm without seeking further power or wealth. (Photograph by Jordan Rolfes.)

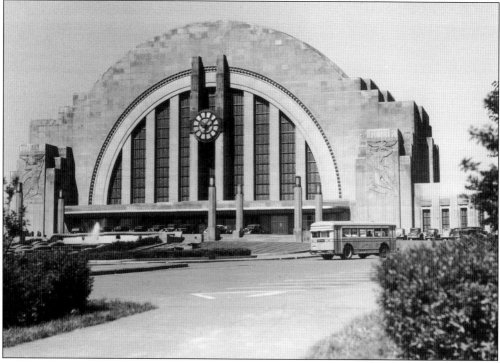

Not everyone was impressed with the magnificence of Union Terminal. The Cincinnati (later Chicago) architectural historian Carl W. Condit had little use for the facility. Somehow forgetting flood troubles, he complained that the ornate structure was located too far from downtown. (Courtesy of Phil Lind.)

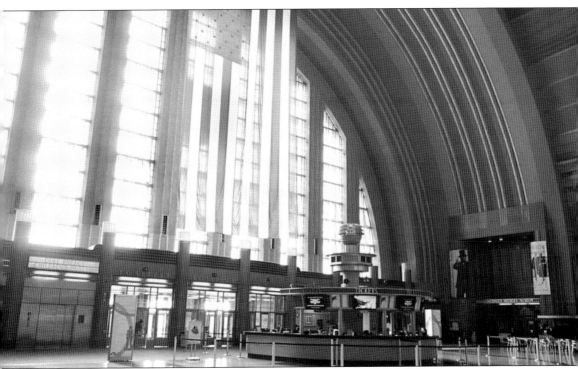

There are countless wartime stories concerning tearful farewells to young men going off to fight the war and many joyful reunions upon their return. One of the most amazing wartime tales concerns Edgar, a young serviceman from Price Hill. Stationed in Virginia, he learned that the train his company would be traveling on would stop at Union Terminal. However, like all troop movements, he could not tell anyone. Determined to see his family one more time, he knew that he could not telephone or write. As the train pulled out of the station in Virginia, he scribbled a note and handed it out of the window to a complete stranger, asking her to send this as a telegram to his folks in Cincinnati. Amazingly, it worked. Upon his arrival at Union Terminal, Edgar was surprised to learn that not only was his family there wanting to give him a hug, but about 500 other people to cheer on the troops. There was also a very angry commanding officer. (Photograph by Jordan Rolfes.)

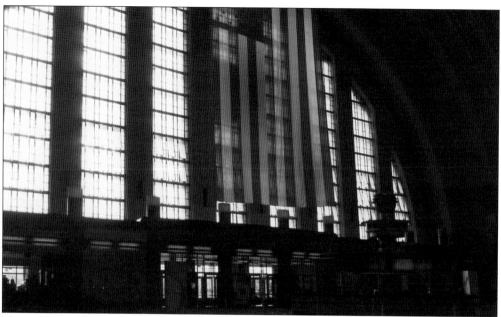

Union Terminal is now the Cincinnati Museum Center. Children rush about, wanting to explore the cave in the Natural History Museum or board the steamboat in the Cincinnati History Museum. One should pause to remember the many young men who embraced their loved ones here, some for the final time before going off to war. Sometimes, when the rotunda is quiet, the sadness can still be felt. (Photograph by Doug Weise.)

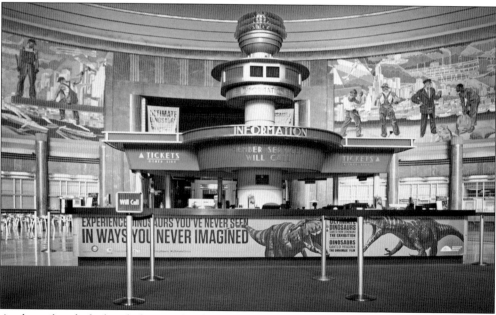

As the railroads declined, the people of Cincinnati wondered what to do with this magnificent but now unimportant building. The term *white elephant* was often used as politicians debated turning the structure over to the wrecking ball. Thankfully, in 1972, it was named to the National Register of Historic Places; in 1977, it was designated as National Historic Landmark. In 1990, it opened as the Cincinnati Museum Center. (Photograph by Doug Weise.)

Union Terminal was a marvel to behold and served the nation well in the dark days of World War II. However, when the thousands of servicemen returned home through the great rotunda, the world was soon to become a very different place. Postwar Americans soon wanted the freedom of driving their own cars rather than depending upon rail service. (Courtesy of the Mount Healthy Historical Society.)

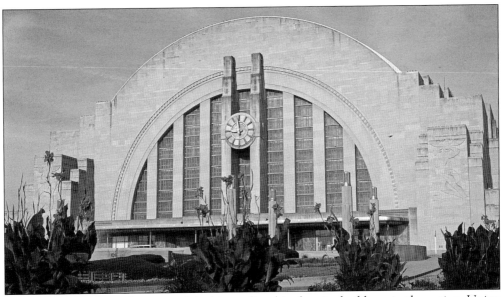

In 2006, the American Institute of Architects listed its favorite buildings in the nation. Union Terminal clocks in at number 45. The only other Ohio structure in the list is Paul Brown Stadium, also in Cincinnati. Union Terminal was the fifth Art Deco structure in the list, beaten by such treasures as the Chrysler Building. The number one Art Deco pick was the Empire State Building. (Courtesy of the Kenton County Public Library, Covington, Kentucky.)

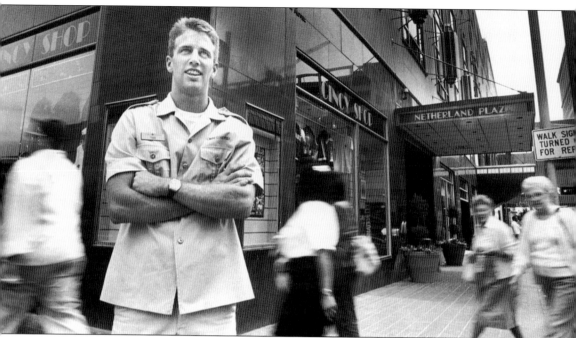

As this man stands at the corner of Fifth and Race Streets downtown, he does not seem to be aware that Cincinnati's second great Art Deco treasure is located right behind him. The truth is, he knows darn well about the wonder behind him. He is Todd Northcutt, one of the doormen who greeted visitors to the amazing hotel called the Netherland Plaza, now the Hilton Netherland Plaza. Northcutt was photographed because he had become an accidental hero when he assisted the police in capturing a robber. (Courtesy of the Kenton County Public Library, Covington, Kentucky.)

Three
THE NETHERLAND PLAZA

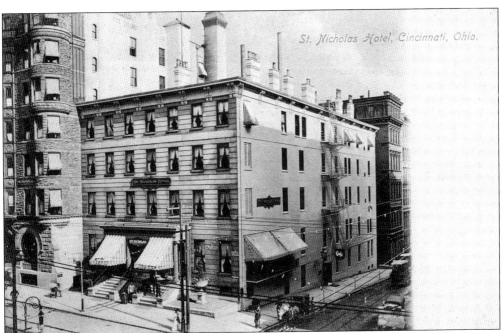

Since opening in 1865, the Queen City's most luxurious inn was the tiny St. Nicholas Hotel on Fourth and Race Streets. When it closed in 1911, the prestigious name was quickly purchased by the Hotel Sinton. This led to a heated legal battle with the owners of the newly constructed Netherland Plaza, who originally intended to use the St. Nicholas name. (Courtesy of the Public Library of Cincinnati and Hamilton County.)

While everyone is familiar with the Art Moderne Union Terminal, there is a second great Art Deco treasure in the Queen City: the elegant Hilton Netherland Plaza hotel. An integral part of the Carew Tower complex, this hidden gem is located in the very center of downtown, right across the street from Fountain Square. The Netherland has been a part of Cincinnati history for more than 80 years. Those who enter—either as visitors from other cities, people attending a meeting or a wedding reception, or to have a fine meal in one of the restaurants—the Netherland are transported into a world of elegance and style. Seen here is French Art Deco in its most mesmerizing form. The visitor will experience a spellbinding display of design, from classical murals on the ceiling to Modernistic fixtures on the lights and railings. If the other guests were not looking at smart phones, one would expect to see F. Scott Fitzgerald in a tuxedo walking by to have dinner in Orchids. (Courtesy of the Hilton Netherland Plaza.)

The Netherland was the brainchild of one of Cincinnati's most notable residents, John Emery. His grandfather, Thomas, arrived in Cincinnati in 1832 and sold candles made from the by-products of the stockyards. In 1926, he married Irene Gibson, daughter of the artist who created the famous Gibson girl. (Photograph by Jordan Rolfes.)

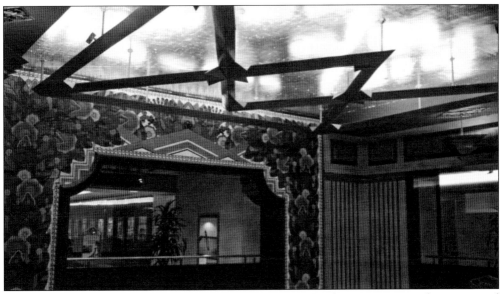

In 1929, Emery approached the banks to request funding for the Carew Tower skyscraper and the Netherland Hotel. The bankers refused the loan. This was not a smart thing to do to a man like Emery. In defiance, he sold his fortune in stocks to fund the project. Soon afterwards, the stock market crashed. Had Emery not made the move, his wealth would have been worthless. (Photograph by Jordan Rolfes.).

The hotel abounds in unusual and Modernist art, sometimes bordering on the surreal. There is a curious tale as to how the Netherland received its rather dreamlike name. The Netherland Plaza actually opened in 1931 without a name. When the St. Nicholas Hotel on Fourth Street closed, the nearby Hotel Sinton quietly purchased the rights to the name. Emery wished to use the coveted St. Nicholas title and spent a fortune having the insignia branded on napkins and silverware. This was stopped by legal action from the Sinton. The Starrett Investing Company had already spent thousands of dollars purchasing napkins and silverware monogrammed "SNP" none of which could now be used. Rather than throw away the expensive material, the "SNP" became the Starrett Netherland Plaza. The "nether" in the new name came from the fact that the hotel was in the middle space between the Ohio River and the surrounding hillsides. In truth, it is in the middle of the downtown area, halfway between the river and the Over-the-Rhine neighborhood. (Photograph by Jordan Rolfes.)

John Emery wanted only the best for his new hotel. He hired two of the finest architects available for the massive project. Col. William Starrett's work was already well known, from the Classical Revival Lincoln Memorial to the massive Art Deco Empire State Building. Fellow designer Walter W. Ahlschlager created Chicago's Hotel Intercontinental and the opulent Peabody Hotel in Memphis, Tennessee. (Photograph by Jordan Rolfes.)

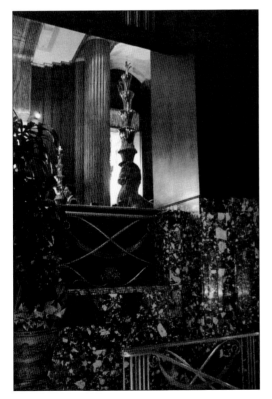

Located in what was once the tallest skyscraper in Cincinnati, the Netherland is 29 stories tall, offering more than 600 rooms for visitors to the Queen City. When the Netherland Plaza opened in 1931, the *Times-Star* proclaimed it to be as magnificent as "the splendors of Solomon's temple." (Photograph by Jordan Rolfes.)

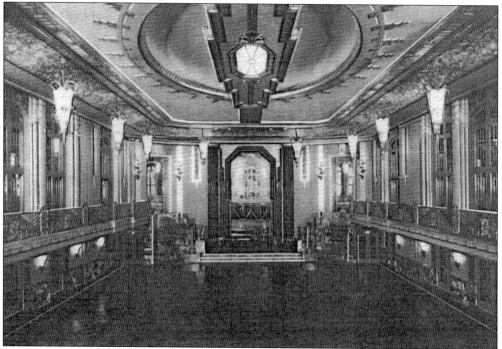

Guests at the Netherland Plaza were given a luxurious booklet describing the amenities of the hotel. No doubt over the years, many of these brochures became treasured keepsakes as reminders of a young bride's big day and the hotel the new couple stayed in. This is one of the many photographs in the booklet. (Courtesy of the Cincinnati Museum Center, Cincinnati Historical Society Library.)

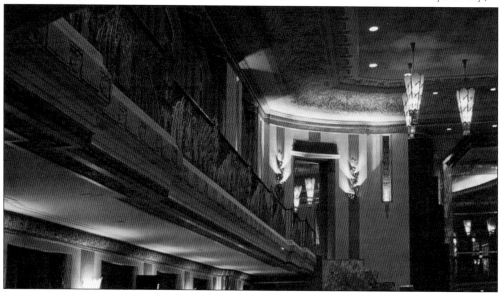

One of the most famous ballrooms is the renowned Hall of Mirrors. While the room is breathtaking, one usually does not notice the ceiling. It was strategically designed by George Unger, creator of New York's famous Roxy and Beacon Theatres. Upon entering, the ceiling is rather low, like entering a theater. Once inside, the room opens up for the visitor like an old-fashioned movie palace. (Photograph by Jordan Rolfes.)

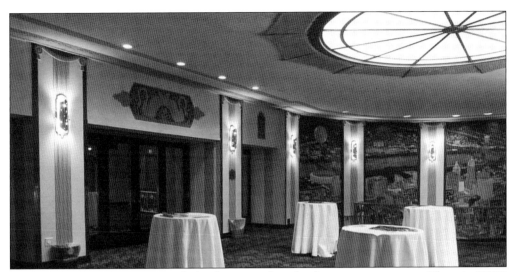

The Netherland is famous not only for the rooms, but also for its meeting spaces. There is 47,000 square feet of room available for gatherings, from the three opulent ballrooms to 28 smaller rooms. Of course, the elegant French Art Deco style is found in even the smallest assembly rooms. (Photograph by Jordan Rolfes.)

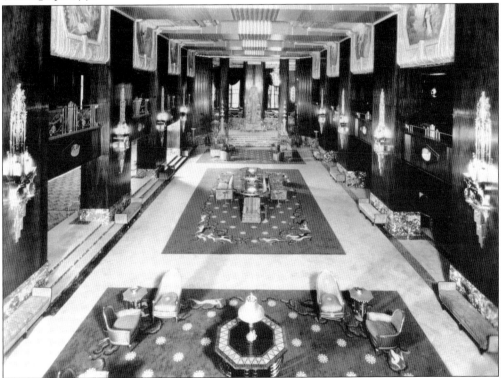

The Netherland was once owned by the Belvedere Hotel chain, whose owners fully appreciated the artistic as well as financial value of the facility. Belevedere's general manager commented on the acquisition, stating, "We realize that we are the guardians of one of Cincinnati's most important treasures. This hotel is an icon in the minds of the people of Cincinnati." (Courtesy of the Ohio Historical Society SA1039AV_B02F1.)

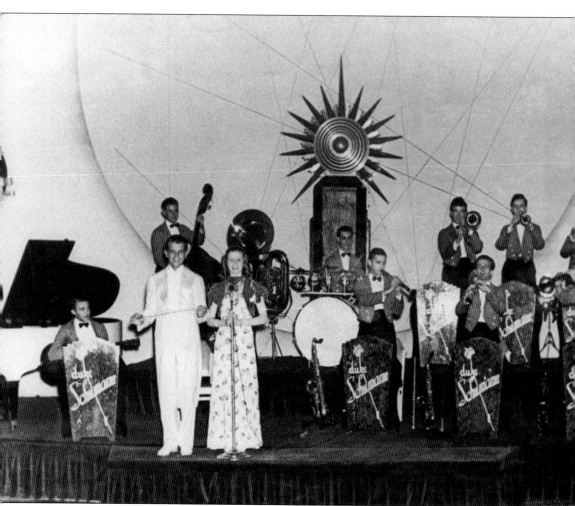

Over the decades, the Netherland has featured many famous acts in its ballrooms, including the premier of a woman who would become a great star. In the late 1930s, a young Cincinnati songstress debuted at the Netherland's Continental Ballroom (then known as the Pavilion Caprice), although patrons of Charlie Yee's Shanghai Inn already knew her talent. This 16-year-old singer, Doris Kappelhoff, went on to become one of the most famous singers of her time, singing one of the greatest ballads of the World War II era—"Sentimental Journey." She later became equally famous as a film star. Of course, by then she had changed her last name, and she is still loved as the singer and actress Doris Day. (Courtesy of the Hilton Netherland Plaza.)

Defying business trends, the Netherland opened for business in 1931, the early days of the Great Depression. Despite the odds being against it, the hotel quickly became a prestigious destination for visitors. The tradition continues today as guests are cared for by a massive staff of 350 employees. (Photograph by Jordan Rolfes.)

Every great hotel has at least one ghost story. People have reported seeing a "woman in green" in the hotel, particularly in the Hall of Mirrors, and sometimes even in the lobby. The story is that her husband was one of the men working on the Carew Tower in 1930 who died in an accident. The ghost is supposedly his wife searching for him. (Photograph by Jordan Rolfes.)

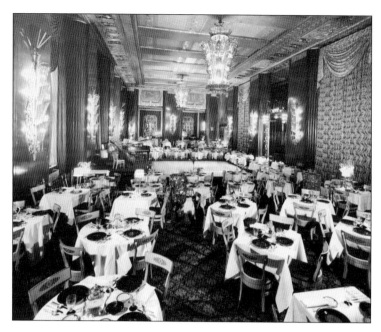

Notice the ice-skating rink in the center of this ballroom. Entertainment has always been at this location in the heart of downtown Cincinnati. When the French Circus closed, the Palace Varieties was located here, providing the public with games, comedians, acrobats, and gambling. Later, the Netherland continued the tradition by offering the public ice-skating shows. (Courtesy of the Hilton Netherland Plaza.)

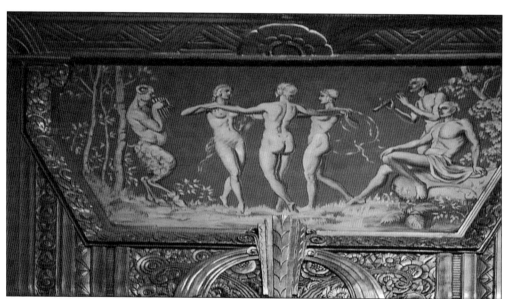

While Cincinnati is famous for being a city of German immigrants, the Netherland receives its artistic inspiration from France. In May 2002, this grand hotel in the French Art Deco style hosted dignitaries from the French-American Trade Council. At this gathering, Cincinnati was granted the new status of being an associate member of the French-American Chamber of Commerce. (Photograph by Jordan Rolfes.)

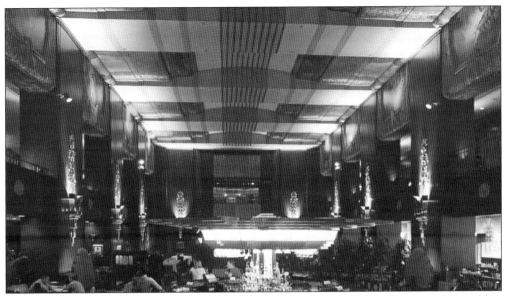

In 1934, Maj. G.S. Black, director of London's prestigious Grosvenor Hotel, toured the world to see what other luxury hotels had to offer. His visit to the Netherland Plaza astonished him. His young niece Eileen Rodgers was even more impressed. Proclaiming that they didn't have anything like this in London, she spent the entire day sitting and looking out of the window at the city below. (Photograph by Jordan Rolfes.)

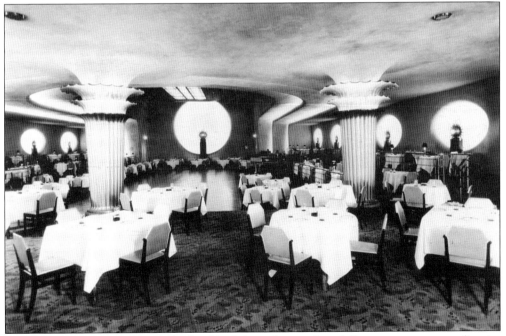

The first guests at the early Netherland had their choice of six different restaurants to dine in, and no less than 26 private dining rooms were available for those who desired privacy. A wedding chapel was conveniently located right next to a ballroom, thus allowing the wedding party to move on with the important business of the reception without delay. (Courtesy of the Ohio Historical Society SA1039AV_B02F14_008_1.)

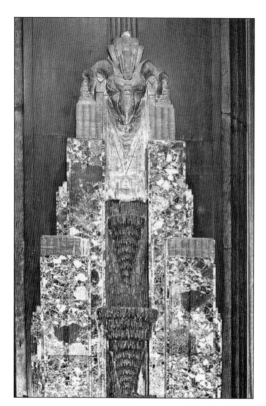

Mythological and classical images are found throughout the Netherland. In Orchids Restaurant in Palm Court, the meals are served amidst Rookwood fountains and murals of a Mediterranean countryside. Diners are watched over by this stunning Art Deco depiction of a goat that is reminiscent of the mythical Golden Fleece. (Photograph by Doug Weise.)

While the Palm Court may battle with a few other prestigious restaurants as to who exactly has the most extensive wine list, there is no doubt as to who has the freshest honey. Fanatic about quality, the Netherland receives its honey from a very local source—its own roof. Tucked away on the sixth floor roof are two beehives. (Photograph by Jordan Rolfes.)

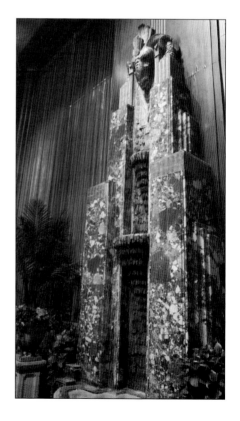

There is a curious irony to this Modernist statue of a mythical sea horse found in Palm Court. The hippocampus, or sea horse, is reminiscent of the symbol of the zodiac sign Capricorn, charging and ambitious with its roots in the water. Cincinnati was born when the first permanent settlers landed at Yeatman's Cove on December 28, 1788, thus making the city of Cincinnati a Capricorn. (Photograph by Jordan Rolfes.)

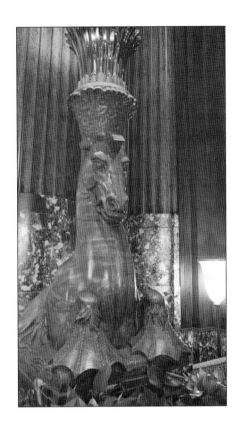

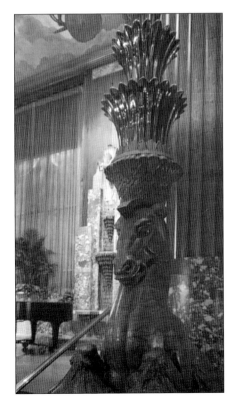

For a short time, the Netherland was known as the Omni Netherland. It was part of the Dunfey Hotels Corporation, a company at one time owned by Aer Lingus airline. The company was founded in 1958 by the Dunfey brothers of New England. (Photograph by Jordan Rolfes.)

The register of the Netherland has the signatures of presidents such as Truman, Eisenhower, and Reagan. One can also find such Hollywood notables as actress Margaret Whiting, along with Cary Grant, Anthony Quinn, and the Mills Brothers. Cowboy singer and actor Gene Autry was particularly fond of the bar. He spent every night in it during his five-day run in the city. (Photograph by Jordan Rolfes.)

Besides presidents, the Netherland has hosted kings and queens. Queen Wilhelmina of the Netherlands was a guest. The king was none other than Elvis Presley. He requested a very well-done burger. The confused chef, wishing to please his guest, reluctantly put the burger into a deep fryer. This obviously worked as the King later walked in to personally thank the chef for his great creation. (Photograph by Jordan Rolfes.)

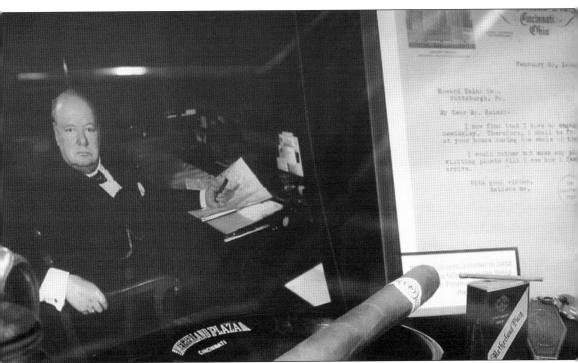

One of the favorite stories from the Netherland, so popular that it is even enshrined in the hotel's display case in the lobby, concerns Winston Churchill's 1932 visit. In the midst of the tour of the suite, he suddenly rushed from the bathroom and grabbed a telephone in utter panic. The manager giving the tour was frightened that some world crisis had erupted and wondered if he should discreetly leave. In truth, Churchill had telephoned his decorator in Chartwell, England, telling him to stop work on the bathroom. He was so enamored by the Art Deco design and color tiles of the bathroom that he requested the plans. He later had his own home's bathroom remodeled to Netherland standards. (Photograph by Jordan Rolfes.)

During World War II, the Netherland's meeting rooms were often used for drives to sell war bonds. In 1945, this man, Capt. Eddie Rickenbacker (shown here with Edith [Mrs. Woodrow] Wilson), was one of the speakers. He fought against the Red Baron, Manfred von Richthofen, in World War I and then was forced down in the Pacific during World War II, obliging him to spend 20 days in a life raft. (Library of Congress LC-DIG-hec-38223.)

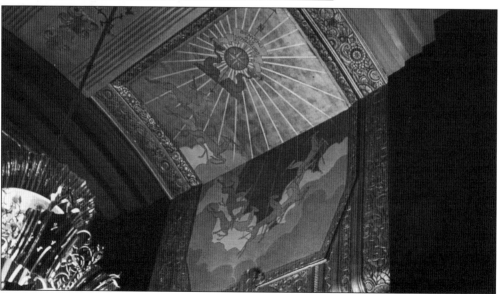

Among the notable events at the hotel was a bizarre experience with First Lady Eleanor Roosevelt. There was a heated argument in the lobby when, not wishing to live off of the taxpayer's dime, she absolutely refused to leave the hotel until she had personally paid the bill with her own money. (Photograph by Jordan Rolfes.)

This street scene outside of the Netherland was once a concert venue. In the 1930s, crooner Bing Crosby's presence in the hotel nearly caused a riot. Rather than accepting the offer of sneaking out through a back door, he gave his fans an impromptu concert while standing on the back of his convertible just outside of the hotel. There was, understandably, quite a traffic jam. (Photograph by Jordan Rolfes.)

By 1981, even the magnificent Netherland showed signs of age. On Christmas of 1981, the hotel was closed for two years to restore it to its original splendor. In the 1960s, a foolish attempt to modernize brought in decorations that were completely out of place with the French Art Deco theme. These were discarded to return the hotel to its previous splendor. (Photograph by Jordan Rolfes.)

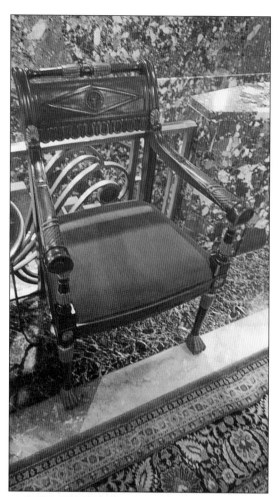

In the 1960s, some Art Deco facilities decided to modernize, obliterating architectural treasures in an effort to keep up with the times. Sadly, even the Netherland succumbed to this. During the restoration work, the massive chandelier in the Hall of Mirrors was accidentally destroyed. (Photograph by Jordan Rolfes.)

A magnificent jewel must have light to shine. Over the decades, a number of windows had been painted over or covered up, creating a somber, almost gloomy setting. By the grand reopening in October 1983, guests were delighted to see that sunlight was now pouring in, illuminating the restored French Art Deco interior. (Photograph by Jordan Rolfes.)

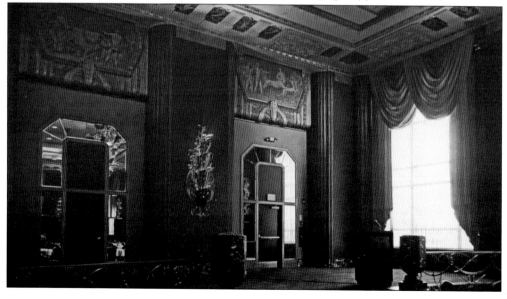

Small details such as the lighting fixtures make sure that wherever guests turn their eyes in the Netherland, they are in the midst of Art Deco elegance. The lighting was revolutionary when the hotel was built, for unlike other illumination in use at the time, the bulbs were concealed. (Photograph by Jordan Rolfes.)

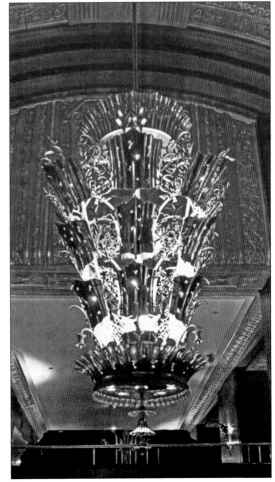

When the hotel was being restored in 1981, the ornate light fixtures found throughout the hotel were not merely cleaned and polished. A professional lighting consultant was called in to supervise this part of the restoration and to assure that the renovated hotel was bright and inviting. (Photograph by Jordan Rolfes.)

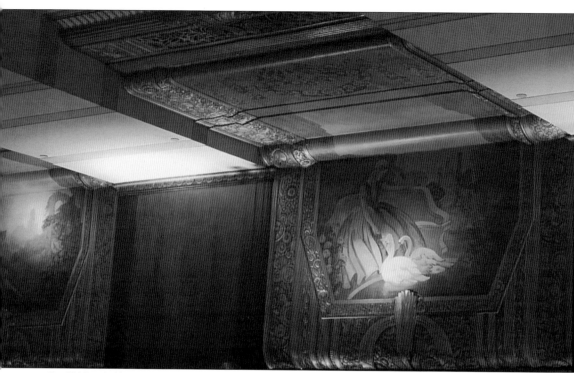

In 1995, nearly 200 people braved a February snowstorm to watch one of the strangest events ever held in the Netherland: the trial of Hamlet. The melancholy Dane was put on trial to see if he was indeed "full of artless jealousy" and guilty of the murder of Polonius. The mock trial featured news anchorman and later mayor of Cincinnati Charles Luken as Hamlet (wearing tights). The mock trial even featured the well-known Hamilton County sheriff Simon Leis presenting evidence. After the presentation, the jury dutifully retired to consider the evidence. The trial ended with a hung jury, which, considering Shakespeare's indecisive hero, fit rather nicely. This is to be expected when a person has none other than the renowned Stan Chesley acting as a defense attorney. (Photograph by Jordan Rolfes.)

Hilton Hotels was in negotiations to purchase the Netherland for two years. At the time that the deal was put into place, Cincinnati was suffering from the lowest hotel occupancy in its modern history, partially due to adverse publicity from a civil disturbance in 2001. Hilton, however, believed in both Cincinnati and the prestige of the Netherland and purchased the landmark hotel. (Photograph by Jordan Rolfes.)

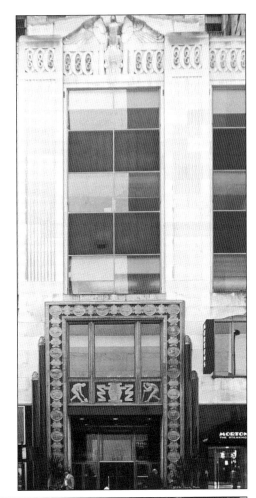

In 2002, the Netherland began the new year with a new owner, Hilton Hotels. The Hilton hotel chain was started in 1919 by Conrad Hilton with one hotel in Cisco, Texas. Over the decades, it grew to become one of the largest, and certainly most prestigious, hotel chains in the world, spanning more than 70 countries. (Photograph by Jordan Rolfes.)

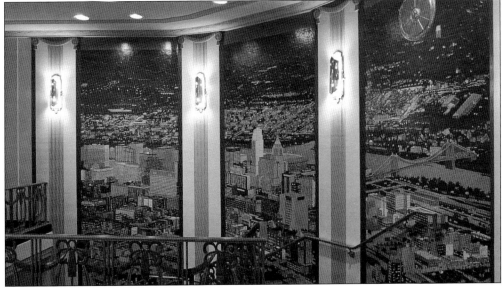

In 2002, the Netherland adopted the celebrated Hilton name as part of its own. Cincinnati's mayor, Charlie Luken, who years before had played the role of Hamlet in a mock trial at the Netherland, declared, "With the reuniting of one of this city's valued landmark hotels with the Hilton brand, we are excited about the additional national and international visibility this provides for our city." (Photograph by Jordan Rolfes.)

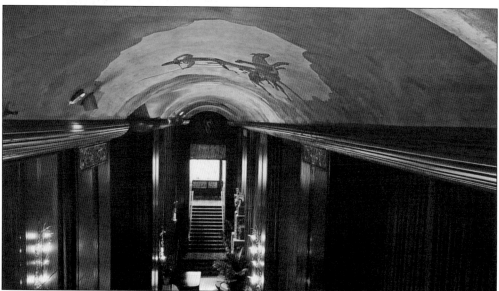

Upon its opening in 1931, the Netherland Plaza enjoyed the distinction of being the largest modern luxury hotel in the nation. At that time, the cost of a single room started at $3, a suite was the astronomical sum of $11. Business travelers' suits could be cleaned and pressed right on the premises using a process known as "odorless cleaning," in other words, dry cleaning. (Photograph by Jordan Rolfes.)

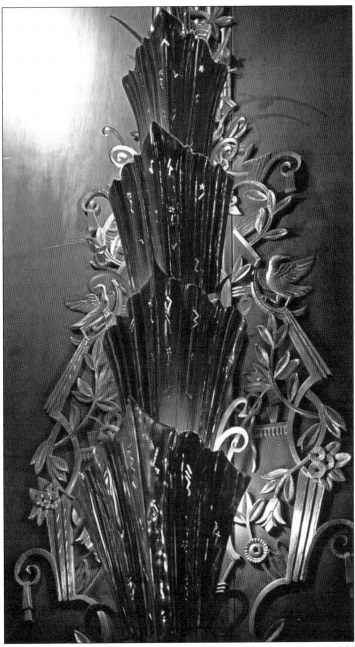

The Netherland has won many awards over the years. In 2001, the coveted Gold Key award was given by *Meetings & Conventions Magazine*. The hotel has won this award not just once, but four times, an achievement not reached by any other hotel in Ohio, Kentucky, Indiana, or Michigan. The competition is steep, as only 169 hotels in the United States and 35 in foreign countries take the prize. Besides the Golden Key, the Hilton Netherland Plaza has gathered numerous other honors. In 1985, it was placed in the list of the National Register of Historic Places, and is designated as a National Historic Landmark. It received the Preservation Honor Award for its remodeling in the 1980s, going far beyond the standards set to receive this honor. In 1989, it was placed on the list of Historic Hotels of America. (Photograph by Jordan Rolfes.)

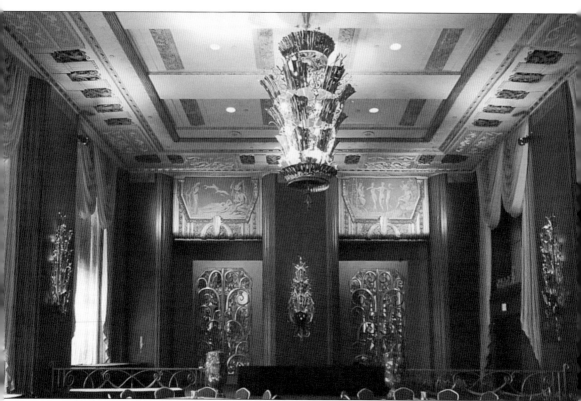

Shown here is one last look at the Continental Room and one last story. The ice-skating rink is gone now, but the elegance remains. The walls of this room are decorated with murals denoting the four seasons. In 1940, a young struggling actor named Dan Tobin hosted a small party in this room to celebrate his new role in the stage production of *The Philadelphia Story*. To his surprise, although he was a new actor with very little money to spend on such luxuries, waiters kept bringing expensive champagne. Tobin became worried that he would not be able to afford this extravagance and asked the waiter. With a smile he replied that the bubbly was provided as a gift from the star of the production, Katharine Hepburn. (Photograph by Jordan Rolfes.)

Four

THE TIMES-STAR BUILDING AND OTHER DOWNTOWN DECO

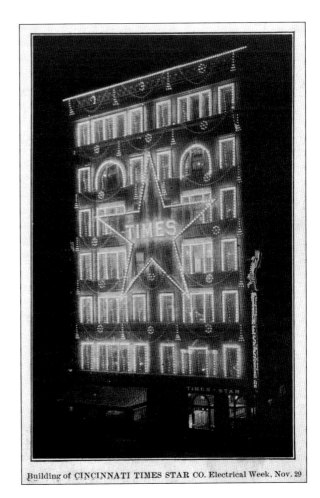

It is apparent from this photograph that the *Cincinnati Times-Star* was looking to the future. One could imagine a person standing at Sixth and Walnut Streets in front of this building at night, reading his or her copy of the newspaper. Within a few years, the firm would give the Queen City its third great Art Deco masterpiece. (Courtesy of the Public Library of Cincinnati and Hamilton County.)

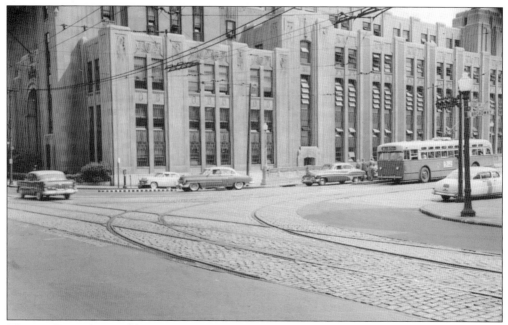
The new Times-Star Building was opened in 1933. Located on Broadway in the northeastern corner of downtown, this overwhelming structure was designed by the famous firm of Samuel Hannaford and Sons. It was placed in the National Register of Historic Places in 1983. (Courtesy of Phil Lind.)

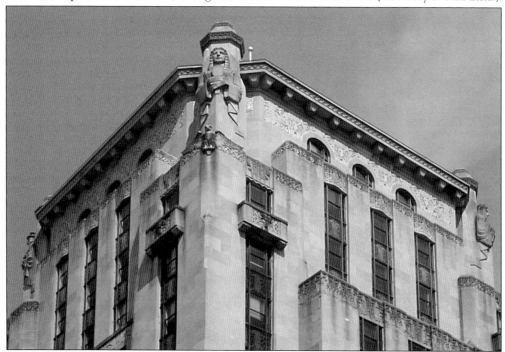
The most unique feature of the Times-Star Building is located near the roof of the structure. There are four megalithic statues of allegorical figures that overlook the city below. These massive sculptures represent Patriotism, Truth, and the favorite themes of the Art Deco period—Progress and Speed. The edifice is 16 stories tall. (Photograph by Jordan Rolfes.)

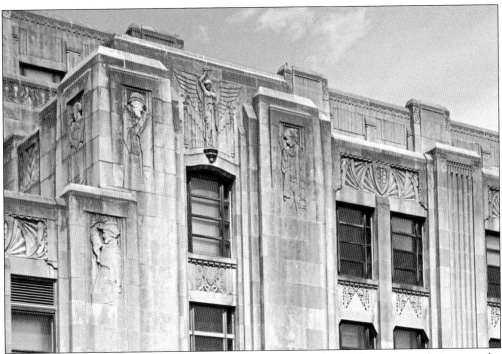

Seemingly every inch of the limestone exterior contains reliefs. The statuary design was the collaboration of Ernest Haswell and Jules Byrs. The *Times-Star* was created when Charles Taft purchased and merged two popular newspapers, *Spirit of the Times* and *Evening Star*. In 1958, it was purchased by the *Post*; it ceased publication in 2007. The building now houses the Hamilton County Juvenile Court. (Photograph by Jordan Rolfes.)

It is interesting to note the similarity between the Times-Star Building on Broadway and the Federal Building a few blocks over on Main Street. While certainly not as overpowering, the government offices do feature similar high, vertical design, particularly in the windows. (Library of Congress LC-USF33-T01-001213-M3.)

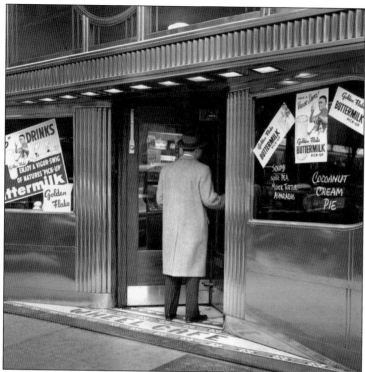

The man walking through the sleek, modern doors is entering the Wheel Café, a beloved Cincinnati institution that, sadly, no longer exists. On April 7, 1933, men started lining up in the early morning to finally have a glass of legal beer. Bartender Louis "Whitie" McCullough said he had never served so many brews to so many men in one day. (Courtesy of the Kenton County Public Library, Covington, Kentucky.)

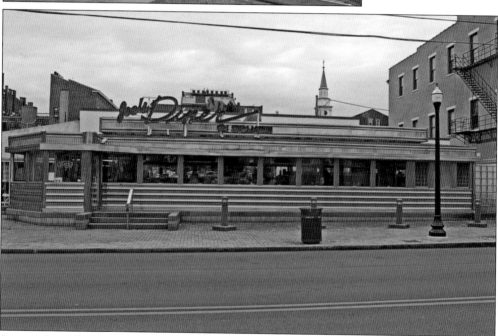

Seemingly in the spirit of the old Wheel Café, this classic diner is located on Sycamore Street in Over-the-Rhine, behind the gothic Alms and Doepke Building. While it looks as though it could have been the inspiration for Edward Hopper's classic painting *Nighthawks*, it is, in truth, quite new. Over-the-Rhine has been undergoing an economic revival with upscale restaurants, nightclubs, and art galleries. (Photograph by Doug Weise)

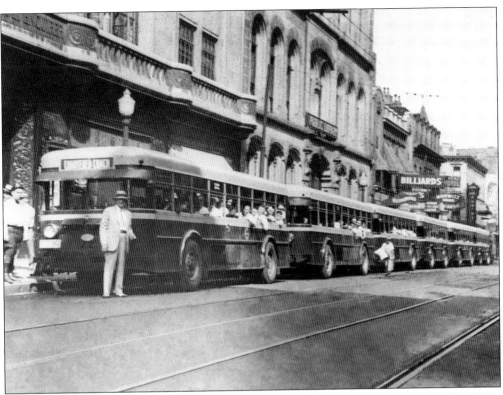

Behind these buses is the entrance to the Enquirer Building. The *Cincinnati Enquirer* had been published from this location since 1866. This building was constructed in 1926. It includes a black marble facade with Art Deco decorations. This is where the fictional radio station was located in the popular television series *WKRP in Cincinnati*. The newspaper moved to a new and larger building in 1992. (Courtesy of Phil Lind.)

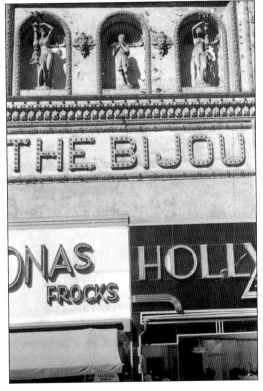

This is a case of street-level Art Deco design being placed over an earlier style. In 1908, Ike Libson constructed the Bijou Theater on Fifth Street on what is now Fountain Square. Starting as a nickelodeon, it expanded to silent films. However, by 1934, it had not received the memo that films were now in sound and could not compete with those newfangled talkies. (Library of Congress LC-USF33-001218-MS).

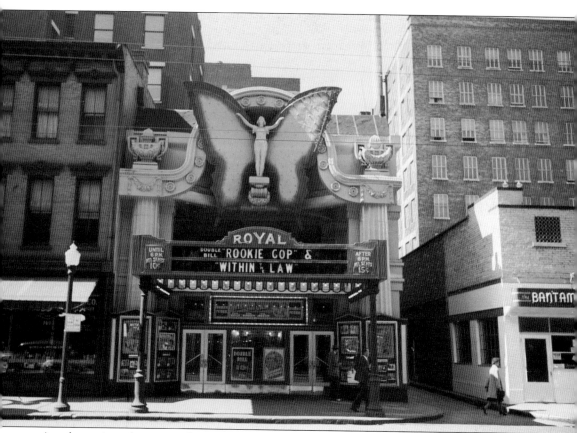

Another unique downtown theater was the Royal on Vine Street. The owner was determined to attract attention, and with a facade like this, how could he possibly miss? Almost every conceivable design style was used in the front, including a massive fairy that lit up at night. In 1911, a reporter for *Moving Picture World* called it "[a] very expensive proposition entirely out of proportion and of rather poor taste . . . the two side columns are a monstrosity, they are heavy enough to support a Chicago skyscraper, while they are out of proportion in a two-story building . . . The top is also heavy even for the big size of the columns, and the crowning butterfly is another monstrosity; in other words, the excellent design of said butterfly is lost in the out-of-proportion effect." Despite the criticism, this delightful example of "art kitsch" became the longest-running theater in Cincinnati, operating from 1910 until 1979. By then, the fairy had long since flown away and the theater was showing soft-core porn films. (Library of Congress LC-USF33-001631-M2.)

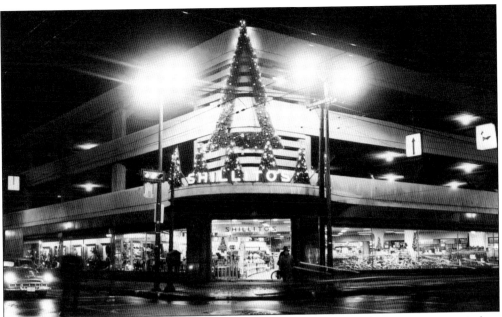

The magic and excitement of Christmas radiates through this famous department store window. For countless people in the Cincinnati area, Shillito's Department Store was synonymous with Christmas. Shown here decked out in holiday glory, the windows on Seventh and Race Streets were overflowing with animated elves, reindeer, and, of course, toys available for purchase inside. (Courtesy of the Cincinnati Museum Center, Cincinnati Historical Society Library.)

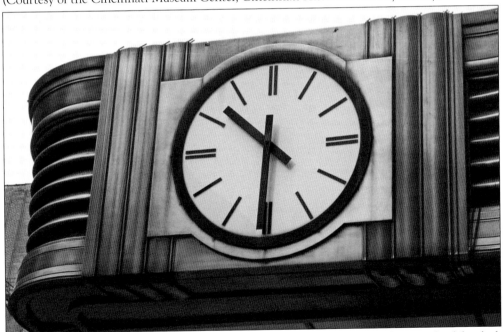

The Shillito's Building is a stunning example of Art Deco, as seen in this photograph of the sleek awning and modern clock. In 1832, Shillito's began as a dry goods department store, then located on Fourth Street. It moved north to Seventh Street in 1878. The Fourth Street location became McAlpin's Department Store. (Photograph by Jordan Rolfes.)

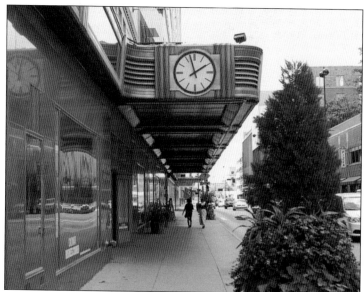

John Shillito had hoped that the move to Seventh Street would lure customers away from other stores on Fourth and Fifth Streets. While popular, the new store was never as successful as hoped. In 1930, the firm was purchased by Lazarus & Company. Today, this Art Deco building houses a business newspaper and has been converted to condominiums. (Photograph by Doug Weise.)

Towering above the other buildings in downtown Cincinnati is the magnificent Carew Tower, which houses the Hilton Netherland Plaza. Construction began a month before the stock market crash and ended in 1931. The building's design is the classic Art Deco skyscraper, similar to New York's Empire State Building. The wedding cake shape allows sunlight to reach Fountain Square across the street. (Courtesy of the Kenton County Public Library, Covington, Kentucky.)

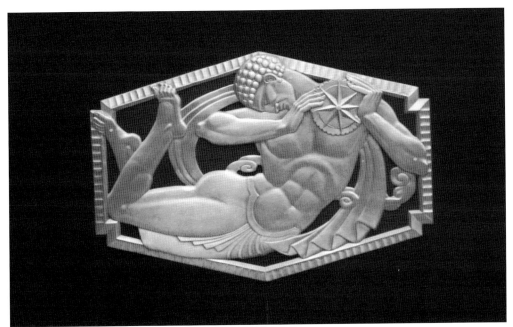

Lovers of Art Deco should definitely take a visit to the Carew Tower. The building features an arcade luxuriously decorated with Art Deco designs, such as these reliefs placed along the balcony of the second floor. There is also a collection of shops and an entrance to the Hilton Netherland Plaza. (Photograph by Doug Weise.)

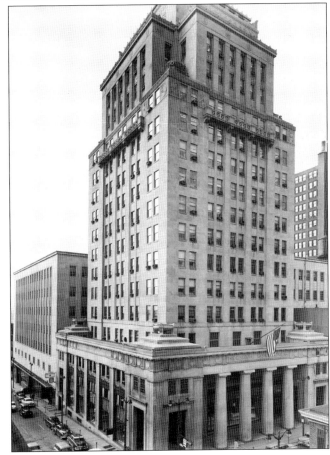

Glancing at this old photograph, one would not think that the Cincinnati Gas & Electric Building on the corner of Fourth and Main Streets was Art Deco. From a distance, it appears to be copied from Greek or Roman architecture. However, looking closer, one sees a very different style, accented by a remarkable series of Modernist decorations. (Courtesy of the Kenton County Public Library, Covington, Kentucky.)

This photograph of the same building may remind some people of a beloved Cincinnati Christmas tradition. The lobby of this complex was a popular Yuletide destination for families to see the display of model trains. The trains have since been moved to the Cincinnati History Museum, where they are presented at the popular Holiday Junction exhibit. (Courtesy of the Kenton County Public Library, Covington, Kentucky.)

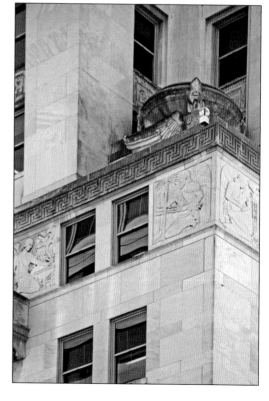

Though it is not visible from the street level, when one is looking at the edifice from higher up, the same building suddenly takes on a very different character. The supposed Classical Revival style is suddenly transformed into an amazing display of Art Deco, with almost invisible carvings of classical figures and four majestic urns. Note the streamline style of the eagle and even the pattern of the stone. (Photograph by Doug Weise.)

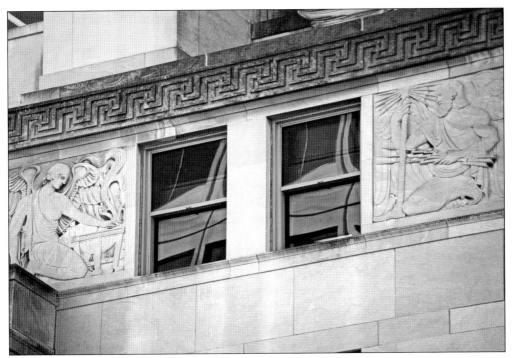

Here is a view that few people are able to see: a close-up of the two allegorical figures from the last shot. The Zeus-like figure on the right holds lightning, depicting electricity; the female on the left rests at a hearth, symbolizing heat. (Photograph by Doug Weise.)

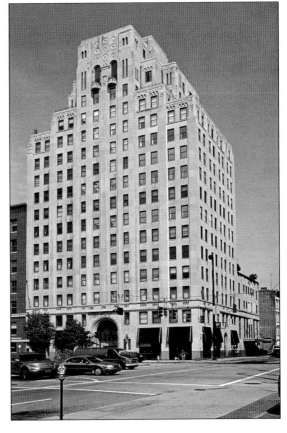

Each day, thousands of people drive by this small skyscraper on the northwest corner of Walnut Street and Central Parkway without noticing any of its mysterious features. This building, completed in 1928, is known as the American Building. Mystical symbols, including a zodiac and a Star of David, are carved into the stone surrounding the archway of the front door. (Photograph by Doug Weise.)

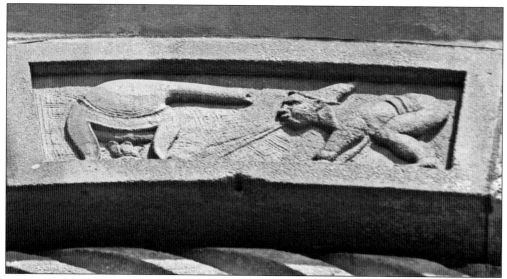

Among the bizarre images on the archway of the American Building is this curious fellow. He was what was called a puffer. Puffers were alchemists who disregarded much of the mystical meaning of alchemy and experimented in what would become the modern science of chemistry. Why one is carved into the doorway of an insurance building next to a zodiac is anyone's guess. (Photograph by Doug Weise.)

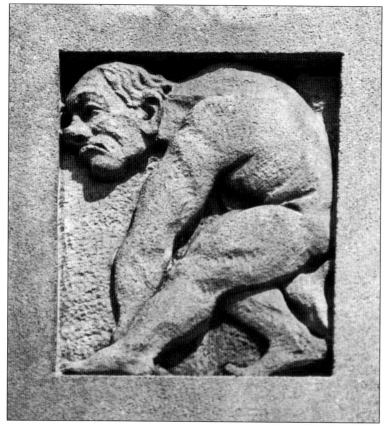

While the Puffer and the zodiac may be perplexing, this figure is a complete mystery. What is he? Note his expression. Is he a primitive man, crouching due to his bestial nature? Or perhaps he the common man in the modern world, bent over from the weight of a technical society, yet determined to use science and spirituality to rise up to some greater state? (Photograph by Doug Weise.)

It is surprisingly easy to walk right past beautiful examples of Art Deco and not even notice them. How many people each day travel down busy Fourth Street, oblivious to this exquisite doorway? Elegant and modern, it is now the entrance to a condominium building. (Photograph by Doug Weise.)

Next to the doorway is a sight that will frighten lovers of Art Deco: construction barriers. Originally known as the Union Trust Building, the Bartlett Building on the corner of Fourth and Walnut Streets was once the tallest building in Ohio. It was constructed at the turn of the 20th century, and an Art Deco facade was added later. By 2010, the building was empty. (Photograph by Doug Weise.)

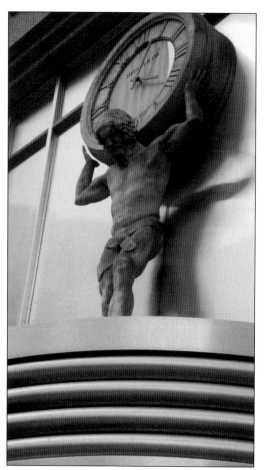

In downtown Cincinnati, Atlas does not shrug; rather, he tells the time. This Art Deco statue is not from the 1930s, but is in fact modern. It graces the entrance of the Tiffany & Co. jewelry store on the corner of Fifth and Vine Streets, across the street from both the Hilton Netherland Plaza and Fountain Square. (Photograph by Jordan Rolfes.)

Architect Henry Hake had more than art in his mind when he designed the Cincinnati & Suburban Bell Telephone Company Building on Seventh Street. Besides the beauty of the exterior, there are strong security measures unseen by the casual onlooker. As if predicting today's world, there are steel doors and covers for the lower floor windows that can be released with the flick of a switch. (Photograph by Jordan Rolfes.)

Cincinnati Bell was certainly proud not only of the artistic facade of its magnificent building, but also the state-of-the-art technical facilities inside. It featured the world's longest straight-line switchboard, with stations for 88 operators. This communication facility became vitally important during the 1937 flood. (Photograph by Jordan Rolfes.)

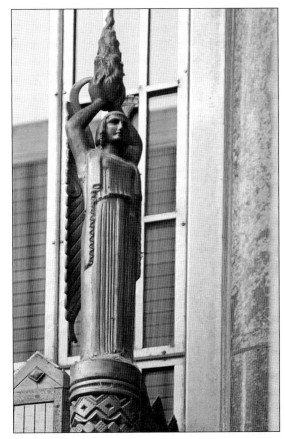

Lovers of Art Deco can locate numerous designs in the motifs carved into the limestone exterior of the Cincinnati & Suburban Bell Telephone Company Building. Among the depictions are French telephones, operator's headphones, messengers running, nautical signal flags, a hare, a swan, and this symbolic image, possibly of Prometheus defying the eagle that the gods sent to punish him. (Photograph by Doug Weise.)

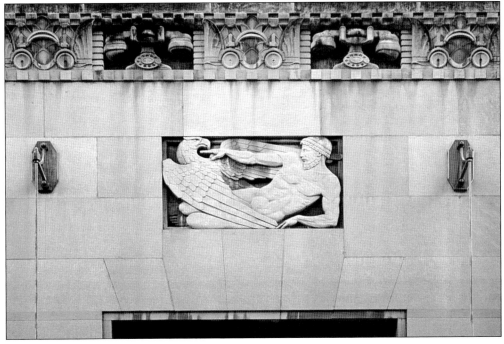

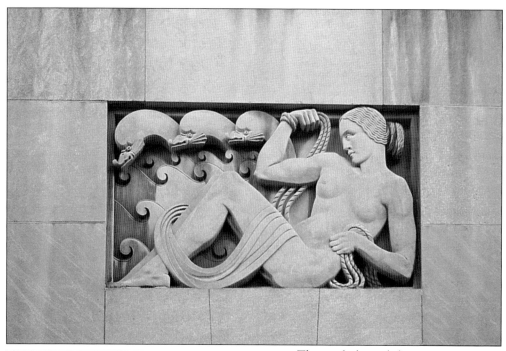

The mythological theme continues on the Cincinnati & Suburban Bell Telephone Company Building with this exquisite depiction of a Nereid flanked by leaping dolphins. While it is certainly a magnificent piece of sculpture, what exactly it has to do with telephones and communication is a question to ponder. (Photograph by Doug Weise.)

While driving out of the downtown area on Central Parkway, very few people notice this tiny Art Deco building. Located near the American Building, it now houses a court newspaper. (Photograph by Doug Weise.)

Five
ART DECO IN THE CINCINNATI AREA

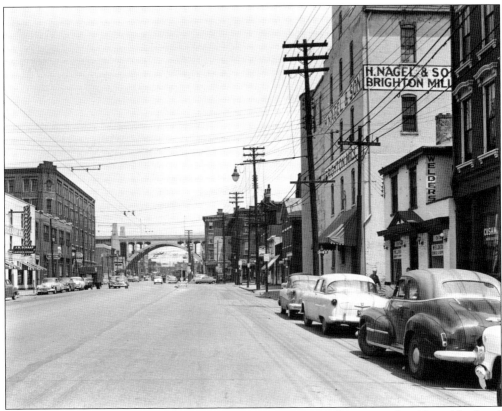

In the background of this picture is an example of Art Deco standing out in the old neighborhood of Brighton. The Western Hills Viaduct with its futuristic light towers was completed in 1932. On the double-decked bridge, the top was for pedestrians and automobiles while the lower deck was originally reserved for streetcars and trucks. (Courtesy of the Kenton County Public Library, Covington, Kentucky.)

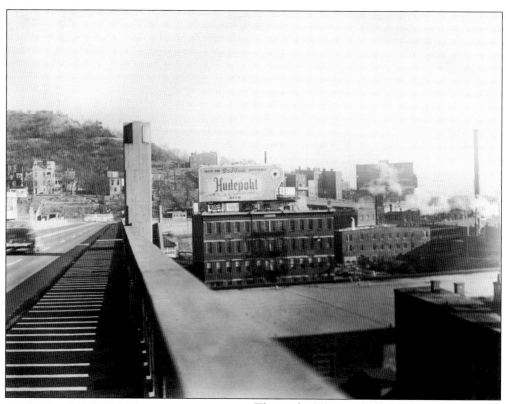

This is the Western Hills Viaduct on the top level, where an Art Deco–style light fixture can be seen. Notice in the background a building with a prominent advertisement for one of the Queen City's most famous breweries, Hudepohl. The beer baron Louis Hudepohl's father wanted him to manufacture medical tools rather than beer. (Courtesy of the Kenton County Public Library, Covington, Kentucky.)

The Western Hills Viaduct has been remodeled over the years, losing much of its original splendor. Here is a recent close-up of one of the Modernist light fixtures, one of the few bits of Art Deco still remaining on the old structure. Sadly, these do not light up any more. (Photograph by Doug Weise.)

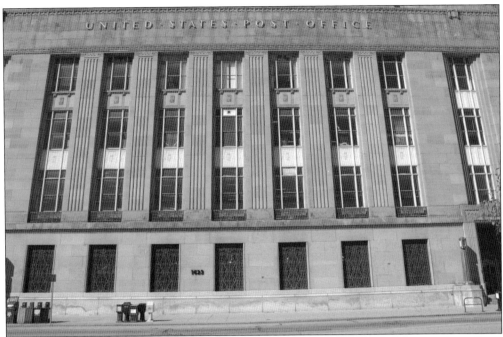

The Dalton Street Post Office, originally known as the Dalton Street Annex, is literally in the shadow of another Art Deco masterpiece, Union Terminal. However, the post office is not outdone by its larger and more famous neighbor. In fact, the two buildings were once connected by tunnels to facilitate mail delivery. (Photograph by Doug Weise.)

The name Hannaford is synonymous with great architecture in Cincinnati. Samuel Hannaford created such treasures as the city hall, Music Hall, the enigmatic Elsinore Tower (actually a pump building for the Cincinnati Water Works), and the Cincinnati Observatory. It was the next generation of Hannafords who created the Times-Star Building and this Art Deco masterpiece, the Dalton Street Post Office. (Photograph by Doug Weise.)

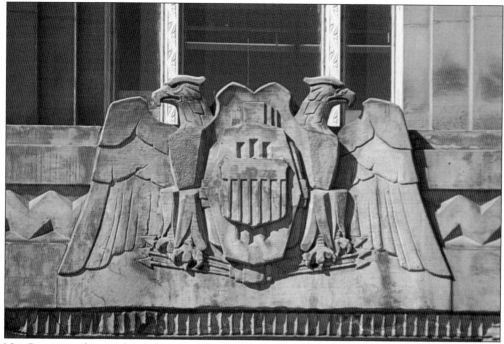

No, Cincinnati has not become part of the Hapsburg Empire. While from a distance it may appear that this majestic bird has two heads, a closer look reveals that it is actually two very American eagles perching right next to each other. (Photograph by Doug Weise.)

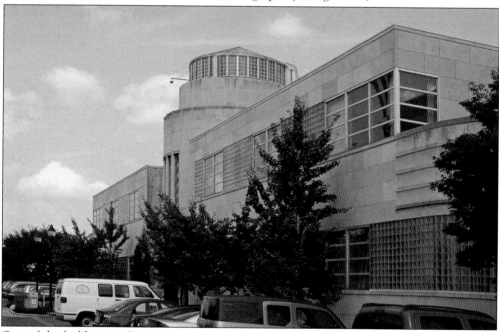

One of the hidden Art Deco treasures in Cincinnati is the Coca-Cola Bottling Corporation at 1507 Dana Avenue in Evanston. It was built in 1938 by the renowned architect John Henri Deeken, a man best known for his opulent mansions in the outlying city of Indian Hills. (Photograph by Jordan Rolfes.)

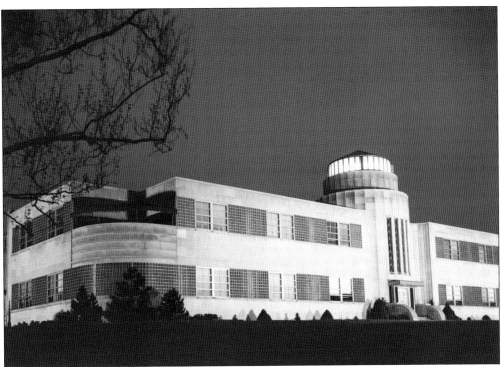

This dramatic nighttime shot of the Coca-Cola Bottling Corporation was the composition of celebrated photographer Paul Briol. The son of a Presbyterian minister in Spencer, Massachusetts, Briol moved to Cincinnati in 1909. His marvelous photographs captured the flavor of the city during the Art Deco age, preserving scenes of steamboats and downtown streets and buildings. (Courtesy of the Cincinnati Museum Center, Cincinnati Historical Society Library.)

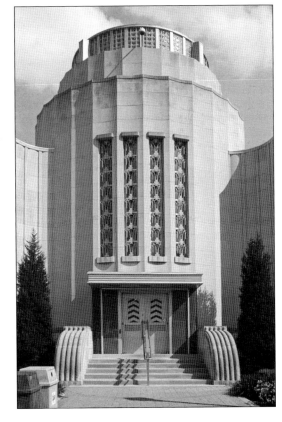

The center of the Coca-Cola Bottling Corporation building, constructed of smooth limestone, features an imposing three-story tower. The lobby inside is two stories tall and features massive murals by artist John Holmer Jr. that depict people in everyday life refreshing themselves with the company's product. (Photograph by Jordan Rolfes.)

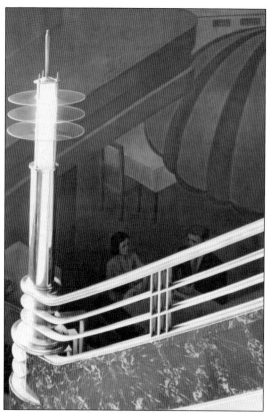

This stunning building was opened with great fanfare in 1938. However, when the bottling works moved, the building fell into disrepair during the 1980s. It was purchased and restored in 1986 by F&W Publications. In 2001, it was purchased by Xavier University and now serves as the Xavier Alumni Center. (Photograph by Jordan Rolfes.)

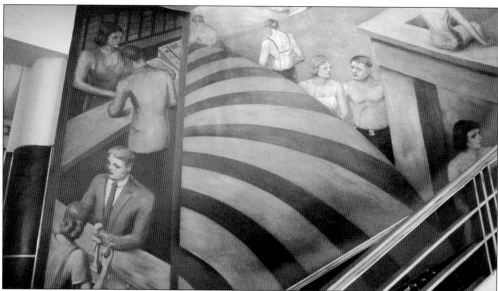

There is controversy behind the huge murals that dominate the lobby of the building. These postwar-era works were the product of John F. Holmer. For some reason, he painted Hitler moustaches on the men and gave everyone a stern expression. The company demanded that the moustaches be removed as this was certainly not the image it wanted to project. (Photograph by Jordan Rolfes.)

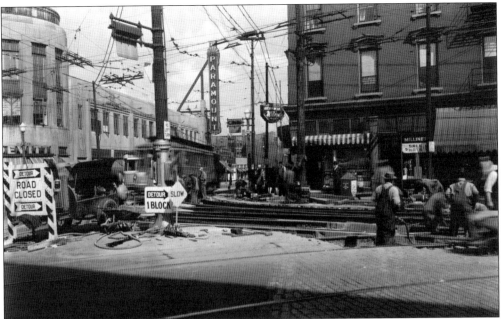

This old photograph was obviously taken before the invention of orange barrels. Looking behind the work on the streetcar lines, one can see the beautiful Paramount Theater at Peebles Corner. Peebles Corner was once one of the busiest crossroads in Cincinnati, a logical place for an Art Deco movie palace. (Photograph by Rombach & Groene, courtesy of Phil Lind.)

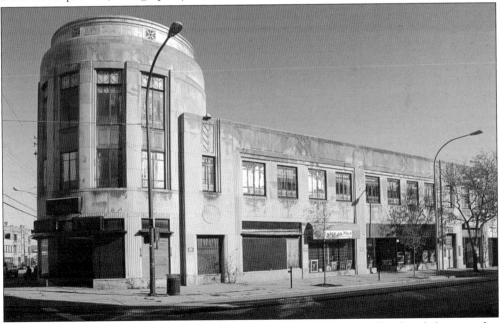

Here is a view of the building as it looks today. As with so many neighborhood theaters, this facility has been replaced by the modern multiplexes. The building, too beautiful to tear down, has remained over the years as the home for a number of businesses. Most recently, it was a pawnshop, but as the surrounding neighborhood has declined, the once great structure is now empty. (Photograph by Doug Weise.)

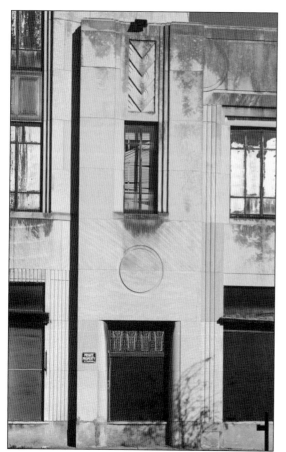

This is a close-up of the McMillan Street side of the Paramount Theater Building. This intersection was once extremely busy, featuring Peebles Grocery Store. Peebles shrewdly bribed streetcar conductors with free cigars, asking them to call out the intersection as Peebles Corner, thus advertising his store every time a streetcar went by. The name has remained long after the store has vanished. (Photograph by Doug Weise.)

One thing that people should always look at when observing an Art Deco building is the metalwork. While the building itself may be streamlined and devoid of ornamentation, metalwork is one spot where design can run rampant, as in this example from the Paramount Theater Building. (Photograph by Doug Weise.)

Need a haircut? A block east of the Paramount Theater Building is this curious establishment. A look at the entire structure reveals that it is certainly much older than the Art Deco period. However, at some point during the heyday of Peebles Corner, the owner decided to modernize the facade with elegant black tile and these intriguing designs. (Photograph by Doug Weise.)

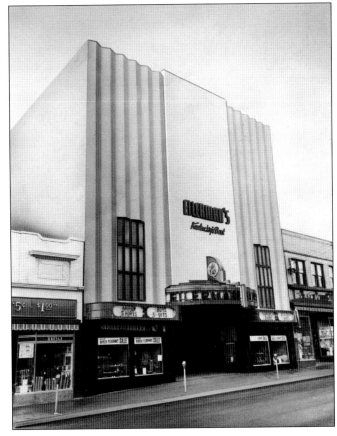

Like the Art Deco Shillito's Department Store in downtown Cincinnati, Eilerman's in Newport, Kentucky, resided in a Modernist building that told customers this was the place to purchase the most current styles. (Courtesy of the Kenton County Public Library, Covington, Kentucky.)

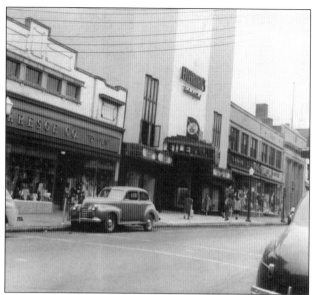

This view of the Eilerman's Department Store in Newport, Kentucky, shows how its Modernist appearance contrasted with the more traditional surrounding businesses, such as the Kresge store right next to it. The round shape above the door is not a clock, but rather a royal figure promising men that they will dress like a king after shopping there. (Courtesy of the Kenton County Public Library, Covington, Kentucky.)

When Eilerman's Men's Stores opened its Covington location on October 7, 1896, it was determined to make an impression. Announcements proclaimed that on the first day no merchandise would be sold. However, there were souvenirs for all. "We have spared no expense to make the day a memorable one . . . and have on that occasion secured the services of a full brass band." (Courtesy of the Kenton County Public Library, Covington, Kentucky.)

While the aisles and display cases of Eilerman's Department Store show a Modernist appearance, someone forgot to look up. From this angle, it is obvious that the lighting fixtures are holdovers from an earlier period. (Courtesy of the Kenton County Public Library, Covington, Kentucky.)

Department stores want customers to come into their establishments and to do all of their shopping—and a little unplanned purchasing—within their walls without leaving. Thus, such stores try to have sleek, bright aisles and displays. Here, the owners hope that the modern design of their sales floor will encourage shoppers to linger. (Courtesy of the Kenton County Public Library, Covington, Kentucky.)

This view of the interior of the Eilerman's Department Store gives an excellent example of streamlined Art Deco. Notice the furniture, the ceiling design, and the lighting. Palm trees and other tropical motifs were very popular in the 1920s and 1930s. One wonders if the lady at the table is requesting a cocktail with a little umbrella in it. (Courtesy of the Kenton County Public Library, Covington, Kentucky.)

Sleek and modern, this Covington building comes out towards the viewer. It once harbored the famed five-and-dime Woolworth's. Later, as seen in this old photograph, it housed different businesses, such as this music shop. (Courtesy of the Kenton County Public Library, Covington, Kentucky.)

Shown here is Covington's Madison Theater in its original form. A few years later in 1946, it would be remodeled into a far more Art Deco look. The Ann Sheridan film being shown features a man who would later become president, Ronald Reagan. (Courtesy of the Kenton County Public Library, Covington, Kentucky.)

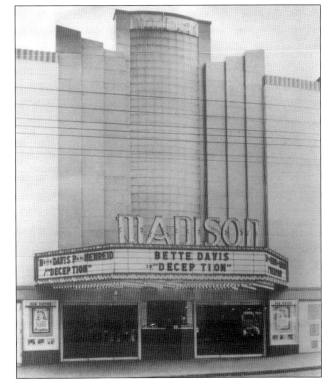

This is a 1946 view of the Madison Theater in Covington, Kentucky. Covington's Madison had recently been remodeled into an up-to-date Art Deco style. Those going to see Bette Davis were now greeted with a high, vertical decoration of shiny tile work, seemingly with wings ready to take flight. (Courtesy of the Kenton County Public Library, Covington, Kentucky.)

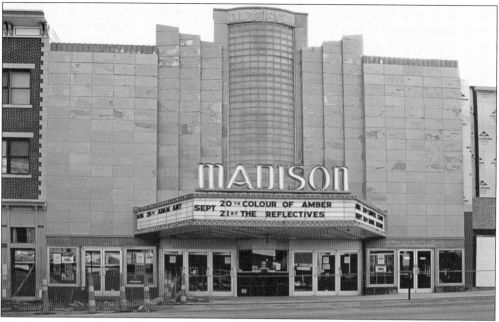

Here is a modern view of the same theater. Although the old building is definitely showing its age, it still reflects the grand Art Deco style. Many great theaters of the Art Deco period were not so lucky. (Photograph by Doug Weise.)

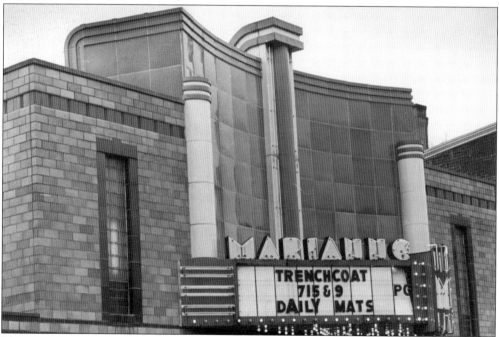

The Marianne Theater in Bellevue, Kentucky, no longer a cinema, first opened its doors in 1942. The Art Deco facade includes a curved wall in sapphire blue tiles, with elegant pillars on each side; even the doors are ornamented by half-moon-style windows. The Art Deco theme continued on the inside of the theater as well. (Courtesy of the Kenton County Public Library, Covington, Kentucky.)

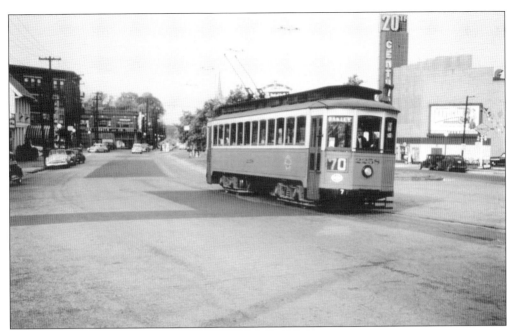

When William Vance's Twentieth Century Theater opened its doors for the first time in 1941, it was touted as being the most modern theater in America. Nine hundred people could be seated to watch the films of the day, beckoned by an 80-foot-tall sign. (Courtesy of Phil Lind.)

John Williams loves to show off the Art Deco interior of the Twentieth Century Theater on Madison Road in Oakley. It struggled to survive as a cinema until it finally closed in 1983. In 1997, it reopened as a concert and multipurpose venue and is now a popular location for wedding parties. (Photograph by Doug Weise.)

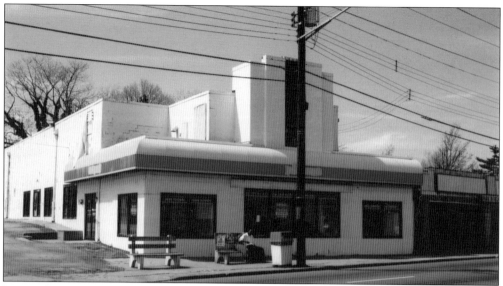
Lovers of Art Deco need to avert their gazes, for this is a scene of tragedy. Look beyond the nondescript front of this vacant store on Hamilton Avenue to see the amazing building within. In the 1930s, it was the stylish Clovernook Theater. Over the years it was a gymnasium, a pizza restaurant, a rental place, and, sadly, the site is now an open field. (Courtesy of North College Hill Historical Society.)

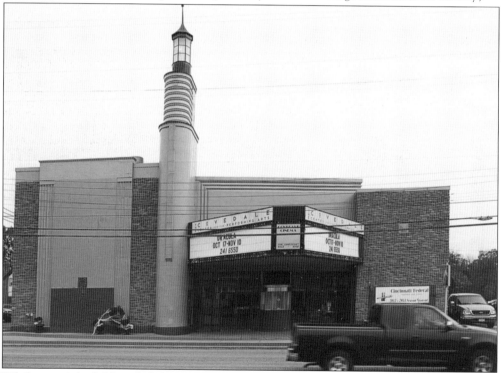
While it may look like a lighthouse, the Covedale on Glenway Avenue is another Art Deco theater that, unlike North College Hill's Clovernook, was able to escape the wrecking ball by becoming a traditional theater. Thus, those who wish to see *Dracula* will watch the stage play, not a film. (Photograph by Doug Weise.)

Here is a close-up of the entrance to the Covedale Theater, showing that even the ticket booth is Art Deco—sleek, modern, and gently curving. In today's world, not only is the style of this structure an antique, but the entire concept of standing outside to purchase admission is often seen as a relic of an earlier age. (Photograph by Doug Weise.)

Here is another neighborhood Art Deco Theater that was given a new life by being converted into an event hall. Now known as the Redmoor, the old Mt. Lookout Theater first opened its doors in 1928. It was known for some time as a venue for avant-garde films. (Photograph by Doug Weise.)

Just up from Mt. Lookout Square is Our Lord Christ the King Church on Linwood Avenue. This marvelous limestone building, designed by architect Edward J. Schulte, is something of a rarity. It is not often that one sees a church building built in classic Art Deco style. (Photograph by Doug Weise.)

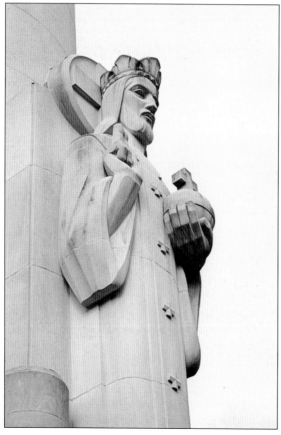

While sometimes one sees Art Deco statues of angels, this sculpture of Jesus in front of the church is an exceptional find. When the parish began in 1926, there was no church building at all. A temporary structure was built a year later. The modern Art Deco church dates to 1957. (Photograph by Doug Weise.)

Mount Washington is the home of this unique bit of Modernism, an Art Deco water tower. Located on Campus Lane, the entire tower is covered with Christmas lights each year. This curious ritual is said to have begun when two drunks dared each other to put lights on the monolith. They put up one strand. Today, the curious tradition continues, though now with thousands of lights. (Photograph by Doug Weise.)

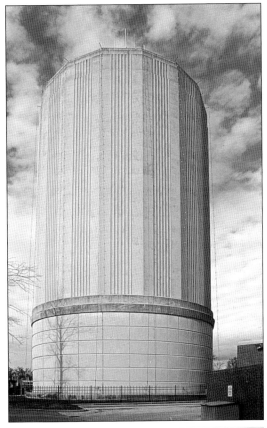

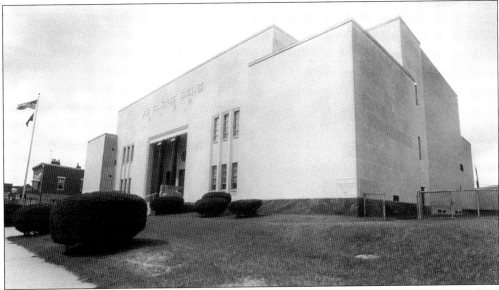

This old photograph does not reveal what is in fact one of the greatest surprises for one searching Greater Cincinnati for Art Deco. While from a distance the Masonic Temple on Madison Avenue close to Fifteenth Street in Covington does not look out of the ordinary, a closer look reveals a hidden treasure. (Courtesy of the Kenton County Public Library, Covington, Kentucky.)

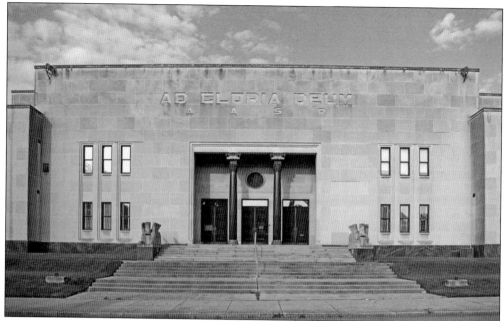

Here is a closer, modern view of the front of the building. From a distance, the casual passerby will assume that those are lions guarding the front entrance. (Photograph by Doug Weise.)

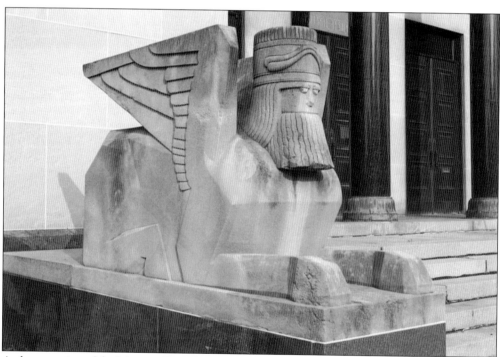

A close-up view of the Masonic Temple reveals a sight that is quite unique—an Art Deco Shedu. Guarding the Masons are two very remarkable statues of the ancient Babylonian spirit, also known as a "lammasu." In ancient Mesopotamia, these angel-like creatures were often placed around temples, palaces, and the homes of wealthy merchants. (Photograph by Doug Weise.)

An Art Deco clock tells young people that it is time to go to school. This impressive building is the First District School, also located in Covington, Kentucky, on Fifth and Sixth Streets. (Courtesy of the Kenton County Public Library, Covington, Kentucky.)

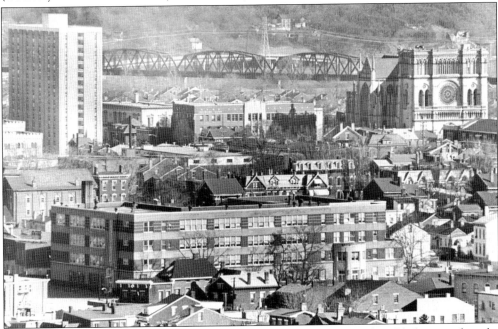

Here is a contrast of styles in Covington, Kentucky. In the middle of this old photograph is the Modernist John G. Carlisle School. Looking up and to the right one can also see the gothic structure of the Cathedral Basilica of the Assumption and the Covington Latin School. (Courtesy of the Kenton County Public Library, Covington, Kentucky.)

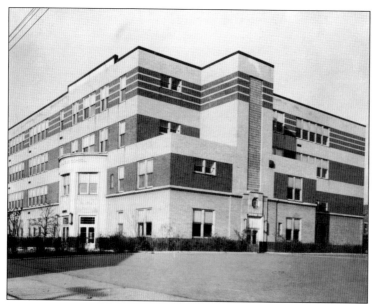

This 1941 photograph of the John G. Carlisle School at Pike and Holman Streets gives a better view of its Modernistic exterior. Here, the streamlined effect goes horizontal rather than vertical. The famed Art Deco "adobe" style is also evident on the side of the building. (Courtesy of the Kenton County Public Library, Covington, Kentucky.)

This photograph from 1940 shows a building in classic Art Deco style with its smooth sandstone exterior accented by long, vertical lines. This effect is mirrored by the tall front windows. Notice the Modernist light fixtures by the front door. This is the Covington Board of Education Building located on Seventh Street. (Courtesy of the Kenton County Public Library, Covington, Kentucky.)

Cincinnati is the largest city in the North that is on the border with the South. This created conflict and division during the Civil War, particularly in the cities across the river in northern Kentucky. The name of this Art Deco school in Covington, shown here in 1932, reflects memories of that conflict; it is the Lincoln Grant School. (Courtesy of the Kenton County Public Library, Covington, Kentucky.)

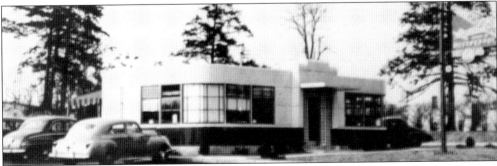

Before reading the rest of this caption, look back at the photograph and try to guess what it is. Although they look quite different today, this is a 1939 photograph of the original Frisch's restaurant, known as the Mainliner, in Fairfax. The modern units still have bits of the modern design and, of course, the Big Boy out front. (Courtesy of Frisch's Restaurants.)

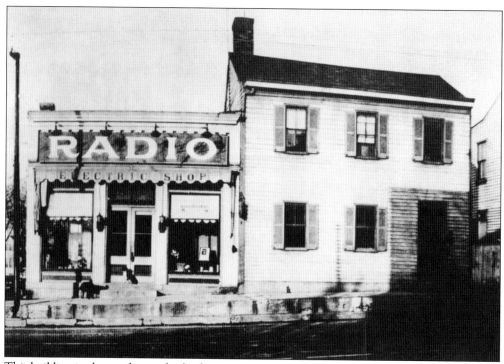

This building in the northern suburbs shows an interesting combination of traditional architecture and a veneer of Art Deco. It proclaims that this is the home of the Information Superhighway of the day—radio. This building still stands and is now a pizza parlor. (Courtesy of the Mount Healthy Historical Society.)

Even streetcars were made in Art Deco style. Car 1100 was delivered to the Cincinnati Street Railway in 1939. At the far left side of this old photograph is the Paramount Theater Building, showing that this particular shot was taken at the main transfer point uptown in Peebles Corner. (Courtesy of Phil Lind.)

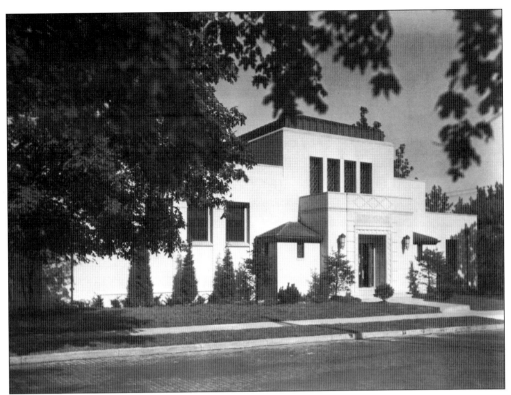

This unique building, the Westwood Branch of the Cincinnati and Hamilton County Public Library, graces the corner of Epworth and Montana Avenues. Library service in Westwood began in 1899 when this was still primarily a farm community and a rural haven for wealthy families such as the Oskamps and the Gambles. This Modernist building was opened in 1931. (Courtesy of the Public Library of Cincinnati and Hamilton County.)

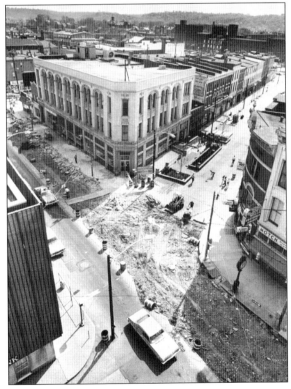

This old building with the Modernist exterior at Pike and Madison Streets in Covington waits patiently for the street in front of it to be repaired and allow customers back in. Someone was either a bad driver or impatient, as he or she knocked one of the orange barrels into the ditch. (Courtesy of the Kenton County Public Library, Covington, Kentucky.)

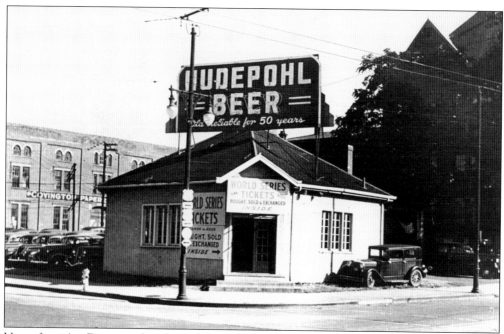

Very often, Art Deco was found in subdued and subtle forms. Those who entered this northern Kentucky shop to purchase their World Series tickets were probably unaware of the horizontal lines and peculiar shape of the Hudepohl Beer sign above the business. (Courtesy of the Kenton County Public Library, Covington, Kentucky.)

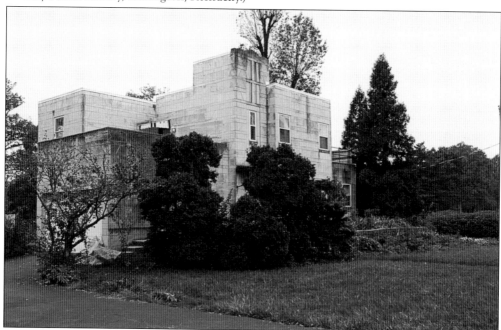

Art Deco architecture can be found in nearly every neighborhood, sometimes in the most unexpected spots. Hidden away amidst the frame houses of North College Hill is this adobe-style building next to the Clovernook Country Club on Galbraith Road, near the border of Colerain Township. (Photograph by Doug Weise.)

On the outside, it does not appear that there is anything particularly Modernist about this simple building. However, taking a look inside may reveal a few surprises. (Courtesy of the Kenton County Public Library, Covington, Kentucky.)

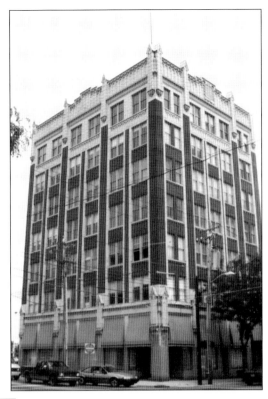

While many Art Deco buildings merely have a modern front placed upon a much older building, others have numerous decorative details. One of these is the interior detail of a grating in a northern Kentucky retail and residential building. (Courtesy of the Kenton County Public Library, Covington, Kentucky.)

While this northern Kentucky structure is an attractive blend of modern, 1950s, and traditional Art Deco with the large vertical entrance tower, it is a building that many people would rather not have to visit. It is the Cincinnati office of the Internal Revenue Service. (Courtesy of the Kenton County Public Library, Covington, Kentucky.)

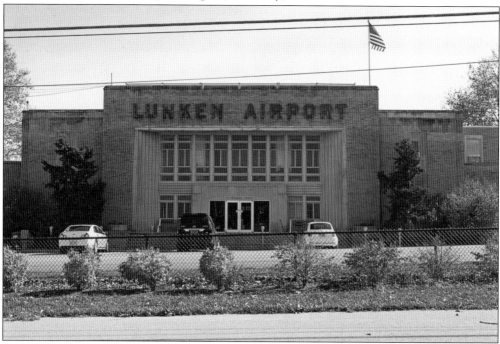

After World War I, a group of veterans leveled a grain field, creating a runway. Edmund P. Lunken purchased the land to create what would two years later become the largest commercial airport in the nation at the time. It was here that the Embry Riddle Flight School was purchased by Aviation Corporation. The new company was soon known by a more familiar name, American Airlines. (Photograph by Doug Weise.)

At four o'clock in the morning on a frigid day in 1937, hundreds of WPA workers were picked up on Central Avenue and trucked to the Beechmont Levy. For hours they stood in the rain and sleet while piling sandbags to hold back the Little Miami River. The river rushed over despite their efforts. The terminal, days away from opening, was inundated. The beautiful decorative plaster walls collapsed. (Photograph by Doug Weise.)

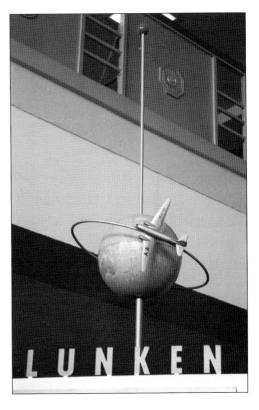

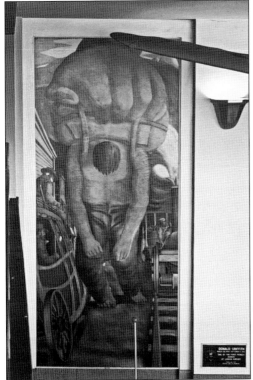

Though the ornate plaster walls became saturated with floodwater, froze, and collapsed, two Art Deco paintings were saved. William Harry Gothard's paintings *Gravity* and *Flight* were rescued before the flood could destroy them. They were completed at Union Terminal and then returned to Lunken. They were designed to match the plasterwork, which was never replaced. (Photograph by Doug Weise.)

The Sky Galley Restaurant in the terminal of Lunken Airport is seen here. Deco and aviation enthusiasts love the Jazz Age setting with a spectacular view of the airfield, not to mention the good food and reasonable prices. Sometimes, people try to spot celebrities arriving in private aircraft. (Photograph by Doug Weise.)

As always, the Modernist lighting fixtures provide a fine addition to an Art Deco structure. This one is part of the Sky Galley Restaurant in Lunken Airport. It illuminates a drawing of biplanes, reminding one of the beginnings of both Lunken Airport and the Art Deco movement itself. (Photograph by Doug Weise.)

While people are overwhelmed by such masterpieces as Union Terminal, one of the most common places to find Art Deco is in four-unit apartment buildings. Examples of these can be found in nearly every neighborhood, ranging from simple, high, vertical decorations with glass blocks to this stunning example of Art Moderne on Luray Avenue near Eden Park. (Photograph by Jordan Rolfes.)

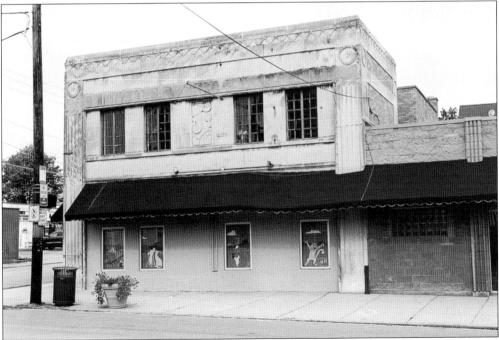

While Art Deco can be found in nearly every neighborhood, certain municipalities are especially rich in the style. Oakley, Roselawn, and the Price Hill/Western Hills areas have many examples of the design. One of these is this building in Price Hill. Notice the decorations near the top. While the edifice is showing some age, the beauty of the era is still there. (Photograph by Doug Weise.)

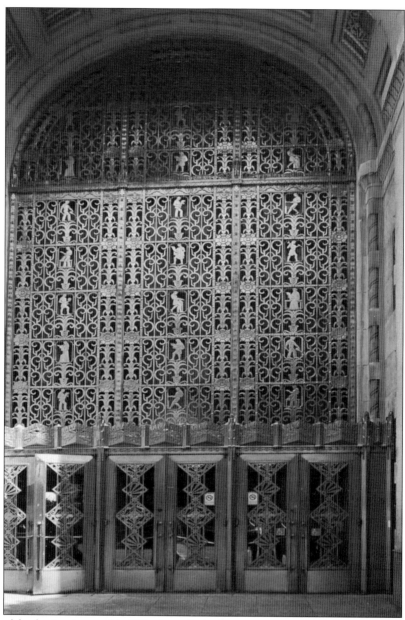

The tour of the fascinating world of Cincinnati's Art Deco comes to a close. The great structures of the 1920s and 1930s speak to people across the decades, reminding them of a time of bootleggers, Prohibition, the Great Depression, and a horrific flood. In their streamlined design, people can still feel the optimism and determination of the generation that faced those challenges of history. Time has moved on—what was once "cutting edge" is now an antique. While the beauty of the buildings is still there, the functions sometimes changed. Union Terminal is now a museum center, the Times-Star Building is a courthouse, elegant neighborhood theaters now feature stage plays and host wedding receptions. In the end, it is the message that is important. History had one more challenge for the Art Deco generation: it was time once again to march off to war. Like the veterans before them, the world would be a very different place when they returned. They would make a new style of art, one whose vision went beyond Art Deco. (Photograph by Jordan Rolfes.)

Six
Cincinnati Postwar Modern

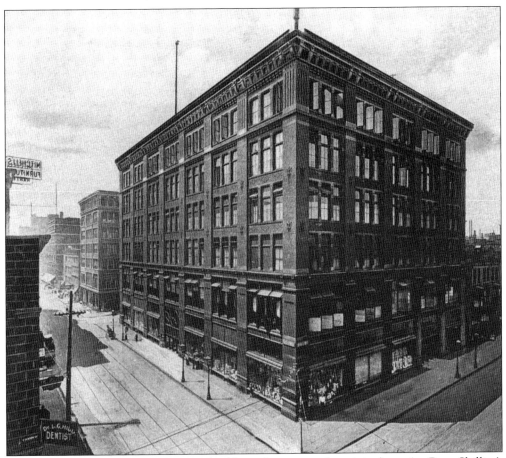

This old photograph shows a glamorous building of a past age, the original pre–Art Deco Shillito's Department Store. After two world wars, the entire concept of elegant changed dramatically. The Gilded Age and even the Jazz Age were now over. The Space Age had dawned, and it needed a new showpiece in the Queen City. (Courtesy of the Public Library of Cincinnati and Hamilton County.)

While Cincinnati has many famous Art Deco structures, it features only one extraordinary postwar modern edifice—the Terrace Plaza Hotel on Sixth Street. Another project of the Emery family, the building was designed by Skidmore, Owings & Merrill to contain "nothing conventional for convention's sake." One designer, Morris Lapidus, later created Miami's Fontainebleau Hotel. The Terrace Plaza was perched atop a base of windowless bricks that contained two department stores, Bond's and J.C. Penney. The round, glass-enclosed gourmet restaurant was decorated with a commissioned mural by the Spanish Surrealist painter Joan Miró, the lobby with a piece by Alexander Calder. These works can now be seen at the Cincinnati Art Museum. The Terrace Plaza opened to great fanfare in 1948, with Thomas Emery throwing away the keys, proclaiming that the hotel would never close. However, it was sold in 1956, the new owners replacing the modern décor with French Baroque. The Gourmet Room exchanged the celebrated Miró for a bust of Marie Antoinette. In 2008, the hotel that "would never close" was shut down. (Courtesy of Phil Lind.)

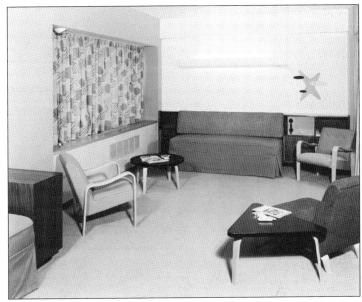

Each room cost $5,000 to construct and furnish. The couch was motorized, sliding out of the wall as a bed. The curious panel included controls for the telephone, the Langevin radio, and a television. Walls between rooms could be raised to create suites. Much of the Modernist décor was covered in a trendy Cincinnati product—Formica. (Courtesy of the Cincinnati Museum Center, Cincinnati Historical Society Library.)

The restaurants at the Terrace Plaza were as unique as the hotel itself. The Gourmet Room with its Miró mural was round and encased in glass, resembling a flying saucer. In the basement below J.C. Penney was the Plaza Cafeteria, a popular lunchtime spot for trendy business people and department store shoppers. (Courtesy of the Cincinnati Museum Center, Cincinnati Historical Society Library.)

Outside of the Terrace Plaza, the Postwar Modern movement was catching on slowly. One place that would often be graced in the new style was the neighborhood bowling alley; the sport became extremely popular with the growing families of the emerging baby boom. (Courtesy of Phil Lind.)

In the postwar society, the neighborhood bowling alley was not only a place for sport, but would also feature excellent restaurants and often a cocktail lounge. Glenn Schmidt's on Fifth Street in Newport with its 24 lanes was certainly no exception. (Courtesy of the Kenton County Public Library, Covington, Kentucky.)

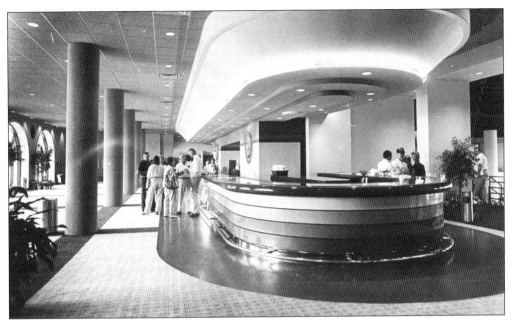

One place that often reflects Art Deco and other Modernist furnishings is a cocktail lounge. This massive 74-foot bar in northern Kentucky's renowned L'Espirt Sales Center, no doubt dispensing one of the Bluegrass State's most famous products, made absolutely certain that sales resistance was reduced to a minimum. (Courtesy of the Kenton County Public Library, Covington, Kentucky.)

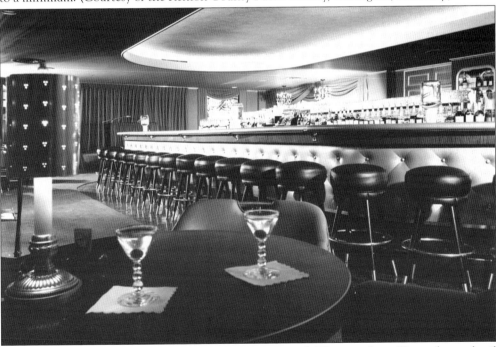

Hopefully, this slice of Americana is shaken, not stirred. This northern Kentucky cocktail lounge with its sleek, modern appearance is reminiscent of the earlier Art Deco period, while the furnishings—particularly the long, steady lighting above the bar—depict the elegance of the 1950s. (Courtesy of the Kenton County Public Library, Covington, Kentucky.)

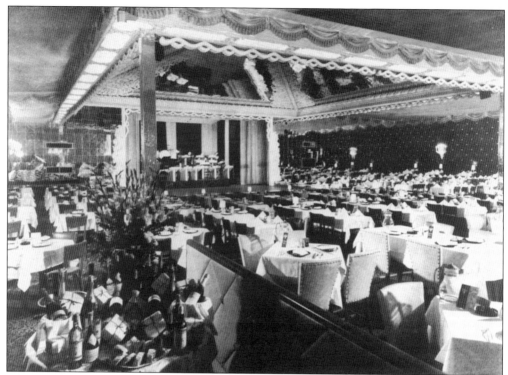

Here is another northern Kentucky restaurant loaded with history and 1950s sophistication. The Schillings family's Lookout House above Covington was indeed a lookout post during the Civil War, finding good use during Confederate general John Hunt Morgan's raid. It was later a tavern and then an elegant restaurant. Sadly, this establishment was destroyed in a fire in 1973. (Courtesy of the Kenton County Public Library, Covington, Kentucky.)

The Beverly Hills Nightclub in Southgate, Kentucky, where Dean Martin was once a blackjack dealer, was one of the most elegant and sophisticated entertainment venues in the Cincinnati area. The facility was twice destroyed by fire, once as arson by organized crime in 1936 and then by an electrical fire in 1977. The second blaze killed 165 people. (Courtesy of the Kenton County Public Library, Covington, Kentucky.)

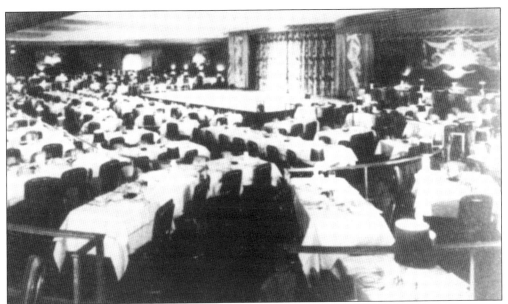

A look at the interior of the 1950s-style Beverly Hills nightclub shows just how dangerous it was when a fire erupted. The crowded showroom became a deathtrap when the fleeing people were bottlenecked. A waiter who rushed onstage to tell people to leave was thought to have been part of the act. (Courtesy of the Kenton County Public Library, Covington, Kentucky.)

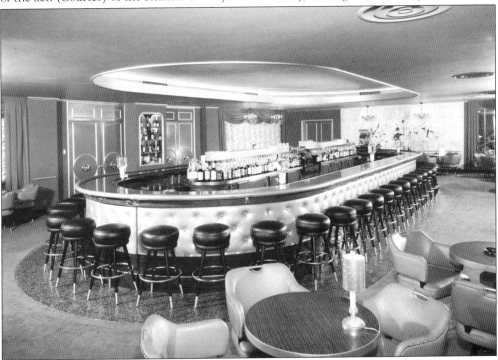

The Beverly Hills was a mecca of elegance in the postwar years. Naturally, it is the bar that best exemplifies this. Note the tiny lamps on the individual tables, the inlaid lighting matching the kidney shape of the bar, and the plush seating for patrons. (Courtesy of the Kenton County Public Library, Covington, Kentucky.)

Nothing brings back the 1950s like the classic flying saucer. This Kentucky home is apparently the *Jupiter 2* (from *Lost in Space*). This very unique building is a private residence. There is only question remaining: Just what does "*klaatu barada nikto*" sound like when spoken with a Kentucky accent? (Photograph by Doug Weise.)

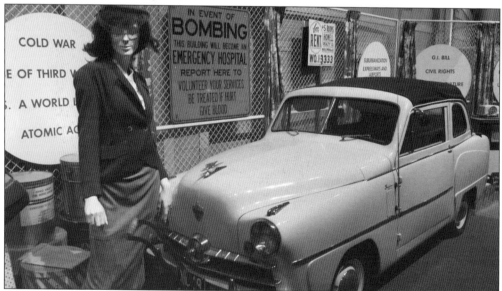

Like Art Deco, Postwar Modern style passed from trendy to antique. There is a display in the Cincinnati History Museum devoted to it. The automobile seen here is a true rarity—a Crosley. Driven by such notables as Humphrey Bogart and Dwight Eisenhower, the vehicle was far ahead of its time and ended production in 1952. In the right corner is the famous Crosley radio. (Photograph by Jordan Rolfes.)

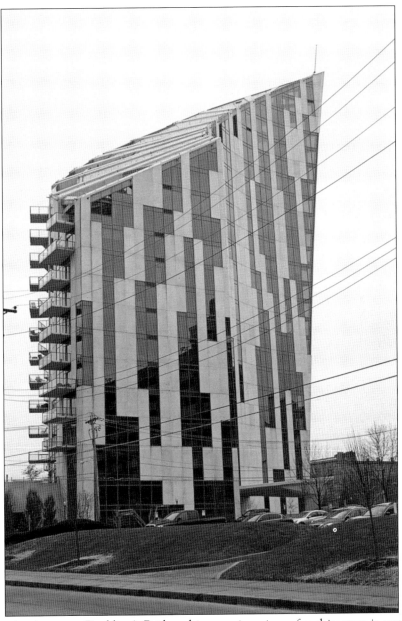

Known as the Ascent at Roebling's Bridge, this stunning piece of architecture is certainly not Art Deco in form; however, it is definitely a modern representation of the Art Deco attitude and the Postwar Modern years. In 2008, architect and former University of Kentucky professor Daniel Libeskind designed this contemporary masterpiece. Like the Art Deco buildings of a previous generation, this reflects not only the nearby bridge (in its time an unprecedented masterpiece), but looks ahead to the future. This building does not merely "scrape the sky," it cuts it like a spear. The design is radical, pulling onlookers gazes up to the heavens, assuring them that all of the great structures have not yet been built. The name signifies high-altitude mountain climbing, the ultimate individual sport where, even in a team, a solitary person is pitted against the world's struggles and hardships to achieve a personal success. That is the spirit and the promise of Art Deco. (Photograph by Doug Weise.)

Discover Thousands of Local History Books Featuring Millions of Vintage Images

Arcadia Publishing, the leading local history publisher in the United States, is committed to making history accessible and meaningful through publishing books that celebrate and preserve the heritage of America's people and places.

Find more books like this at
www.arcadiapublishing.com

Search for your hometown history, your old stomping grounds, and even your favorite sports team.

Consistent with our mission to preserve history on a local level, this book was printed in South Carolina on American-made paper and manufactured entirely in the United States. Products carrying the accredited Forest Stewardship Council (FSC) label are printed on 100 percent FSC-certified paper.